Portraits of Genius Friends

SANDRA HOCHMAN

Turner Publishing Company
Nashville, Tennessee
New York, New York
www.turnerpublishing.com

Copyright © 2018 by Sandra Hochman. All rights reserved.

Portraits of Genius Friends

No part of this publication may be reproduced, stored in a retrieval system, or transmitted in any form or by any means, electronic, mechanical, photocopying, recording, scanning, or otherwise, except as permitted under Sections 107 or 108 of the 1976 United States Copyright Act, without either the prior written permission of the Publisher, or authorization through payment of the appropriate per-copy fee to the Copyright Clearance Center, 222 Rosewood Drive, Danvers, MA 01923, (978) 750-8400, fax (978) 750-4744. Requests to the Publisher for permission should be addressed to Turner Publishing Company, 4507 Charlotte Avenue, Suite 100, Nashville, Tennessee, 37209, (615) 255-2665, fax (615) 255-5081, E-mail: submissions@turnerpublishing.com.

Limit of Liability/Disclaimer of Warranty: While the publisher and the author have used their best efforts in preparing this book, they make no representations or warranties with respect to the accuracy or completeness of the contents of this book and specifically disclaim any implied warranties of merchantability or fitness for a particular purpose. No warranty may be created or extended by sales representatives or written sales materials. The advice and strategies contained herein may not be suitable for your situation. You should consult with a professional where appropriate. Neither the publisher nor the author shall be liable for any loss of profit or any other commercial damages, including but not limited to special, incidental, consequential, or other damages.

Book design: Maddie Cothren

Library of Congress Cataloging-in-Publication Data available upon request

Printed in the United States of America
18 19 20 21 10 9 8 7 6 5 4 3 2 1

For my friends, **Dr. Francis Clifton** & his wife, **Cathy**

TABLE OF *Contents*

ALLEN GINSBERG.................. 2	JULES FEIFFER.................. 50
ANAÏS NIN 4	JULIE ARENAL 52
ANDY WARHOL.................. 6	LARRY RIVERS.................. 54
ARIEL LEVE.................. 8	LEONARD BERNSTEIN.................. 56
ARTHUR MILLER.................. 10	MARCEL MARCEAU.................. 58
CARMEN DE LAVALLADE.................. 12	MARIANNE MOORE.................. 60
DANNY KAYE.................. 14	MILOS FORMAN.................. 62
DICK SHAWN.................. 16	NORMAN MAILER.................. 64
DMITRI SHOSTAKOVICH.................. 18	PABLO NERUDA.................. 66
DOROTHY BUTLER FARRELL.................. 20	PABLO PICASSO.................. 68
ELIE WIESEL.................. 22	PAUL TAYLOR.................. 70
GARY WILLIAM FRIEDMAN.................. 24	PHILIP ROTH.................. 72
GEORGE PLIMPTON.................. 26	RALPH ELLISON.................. 74
GÜNTER GRASS.................. 28	RALPH NADER.................. 76
HAROLD NICHOLAS.................. 30	ROBERT LOWELL.................. 78
HAROLD ROBBINS.................. 32	SAMUEL BECKETT.................. 80
HENRY MILLER.................. 34	SAUL BELLOW.................. 82
IGOR STRAVINSKY.................. 36	SHELDON HARNICK.................. 84
IVRY GITLIS.................. 38	SHERMAN YELLEN.................. 86
JACK KEROUAC.................. 40	SYLVIA FINE.................. 88
JAMES BALDWIN.................. 42	TRUMAN CAPOTE.................. 90
JAMES T. FARRELL.................. 44	W. H. AUDEN.................. 92
JOHN CAGE.................. 46	WILLIAM GREAVES.................. 94
JOHN CHEEVER.................. 48	EPILOGUE.................. 96

Preface

Every genius leads us from darkness into light. Because my destiny led me into marriage with Ivry Gitlis, a concert violinist who was a protégé and friend of Jascha Heifetz as well as a star in the Parisian world of the arts, I had the opportunity to meet many of his genius friends. Later, when I moved back to the United States and won the Yale Younger Poets award, I lived in a world of painters, poets, dancers, actors, and musicians who were busy creating and sharing their magic with me. Andy Warhol said, "The idea is not to live forever, it is to create something that will." Although I've left many people that I knew and appreciated out of this book, it still honors some of the incandescent people in the arts who were busy delivering messages to eternity.

Allen Ginsberg

June 3, 1926 – April 5, 1997

I met **ALLEN GINSBERG** when the late photographer Richard Avedon was taking our picture. Soon after that encounter, we became friends. Allen and his very sweet but conservative father appeared on my radio show *Poems in Print*. The word that best describes Allen is soulful. His poem *Kaddish* is about his mother in a mental hospital and is as powerful as any poem in the English language. Allen often came to my house with a good friend of his, Rabbi Shlomo Carlebach. We all sat on the floor while Shlomo sang some of his songs. Allen was one of the greatest poets of his generation, and he inspired me with his transformation of anger into poetry. You could describe all the addiction and trouble in this country at this time by one of Allen's lines from "Howl": "I saw the best minds of my generation destroyed by madness."

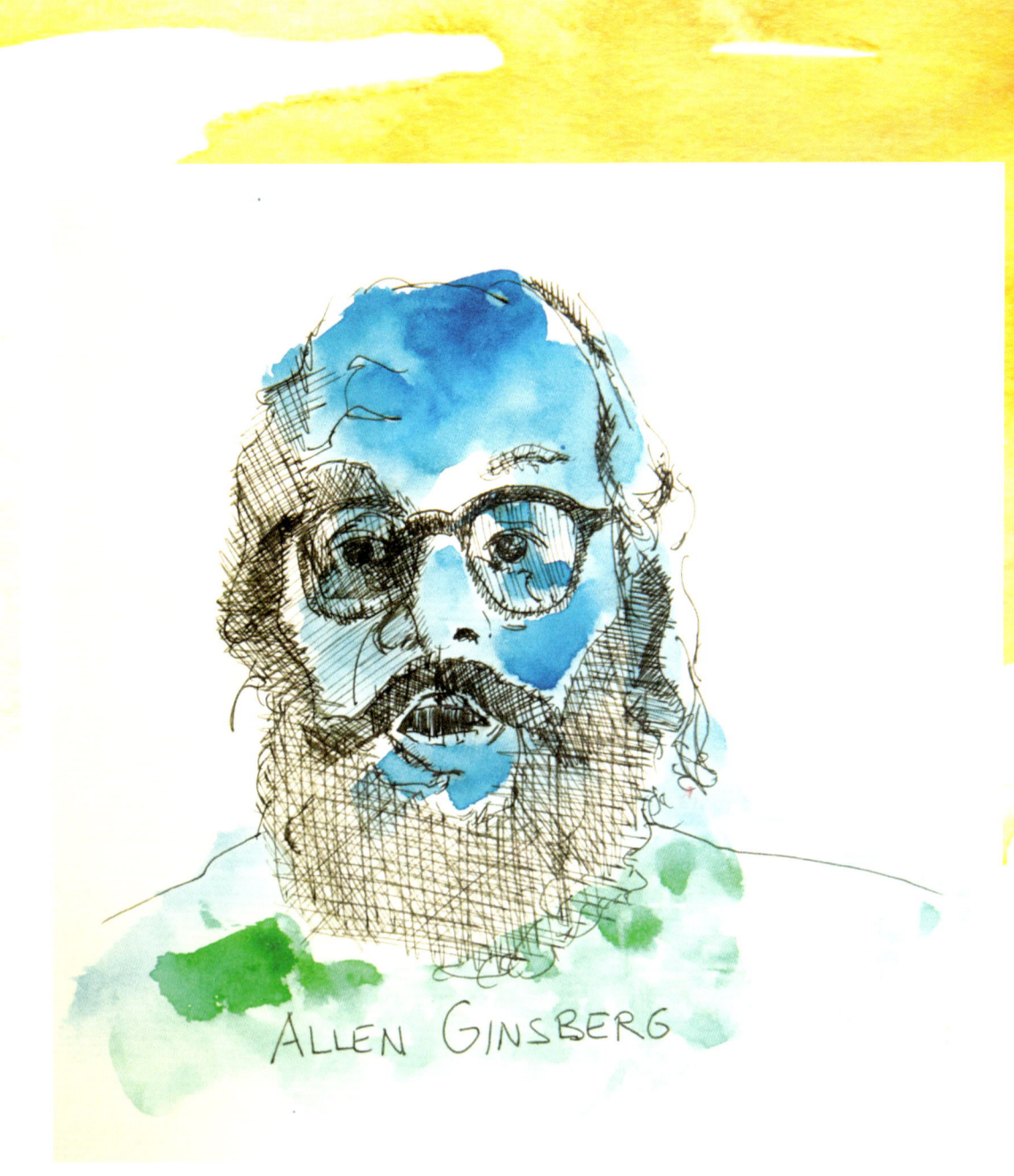

Anaïs Nin

February 21, 1903 – January 14, 1977

ANAÏS NIN was the amazingly beautiful and charismatic Cuban writer. I was lucky to have met her during the book party for her self-published collection of short stories in Paris. For reasons that I will never know, she knew, by just looking at me or by sensing my vibe, that I was a poet. She had this instinct without reading any of my work. Immediately after we met, she published my first book of poems, *Voyage Home*, in collaboration with Lawrence Durrell and Two Cities Press. We remained friends for many years. I repaid Anaïs's kindness by seeing to it that Daniel Stern wrote a cover story of her diary for the literary book section of *The New York Times*. Otherwise it might have gone unnoticed.

Andy Warhol

August 6, 1928 – February 22, 1987

ANDY WARHOL had an assignment from *Vogue* to take a photograph of me. Andy ran after me until I agreed to let him take a photograph of me in a picture booth in Midtown Manhattan. These iconic pictures were recently shown at the Smithsonian. Soon after that encounter, Andy pestered me to come to my home with his sidekick, the poet Gerard Malanga, and make a two-hour silent film of only my lips while I was reading my poetry. The film was titled *Lips*, and I absolutely loved it. We became good friends and I hired his band, The Velvet Underground, for my engagement party and wedding to my second husband.

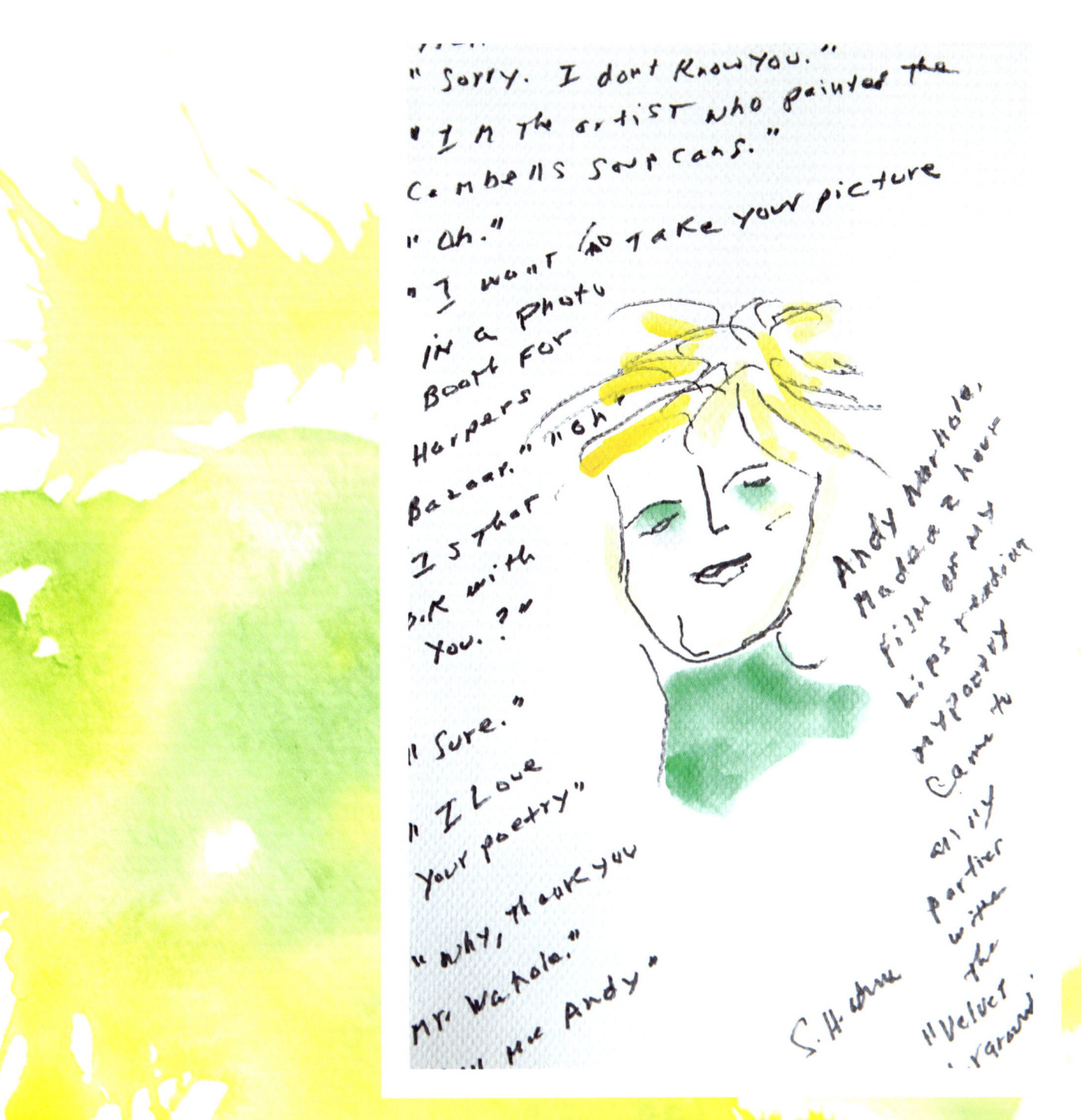

Ariel S. Leve

January 24, 1968

ARIEL LEVE is my talented and beautiful daughter who was born to be a magnificent writer. While growing up, she studied me—writing all the time—and now claims everything she knows about writing she has learned from me. I wrote the first women's humor column for *Harper's Bazaar,* and Ariel followed in my footsteps by having her own humor column in *The London Times*, called Cassandra. Her columns were collected and published in her book by HarperCollins Publishers, *It Could Be Worse, You Could Be Me.* This brilliant book, in my opinion and in the opinion of thousands of others, is one of the greatest humor books ever written and showcases her talent.

My daughter is also a very compassionate journalist. Her journalistic work has included many celebrity articles about writers, directors, and actors. Martin Scorsese requested Ariel to write a book about his career, and I hope that someday it will finally happen. I own a collection of her earliest work that I cherish the most, and I am very proud of everything she writes.

Arthur Miller

October 17, 1915 – February 10, 2005

ARTHUR MILLER had asked me for a favor when I was producing an event called Renaissance Summer with my late boyfriend, Donald Townsend. What was the favor? To give a job to a young poet who was the son of the leading investor for Arthur's film with Marilyn Monroe and Yves Montand, *The Misfits*. I was happy to do that. He rewarded this small kindness by taking me to the opera *Parade* at the Metropolitan with sets by Hockney, my favorite painter. Arthur later invited me to stay for several weekends at his home in Connecticut and asked for me to read my poems aloud to his friends, which I was honored to do. He remained a close friend until he died. Arthur was my intellectual hero, especially after seeing the original productions of *Death of a Salesman* with my father when I was young. This made me want to be a playwright when I got older. I never forgot the sentence about the salesman, "attention must be paid." More attention has been paid to Arthur Miller than any other American playwright. Rightfully so.

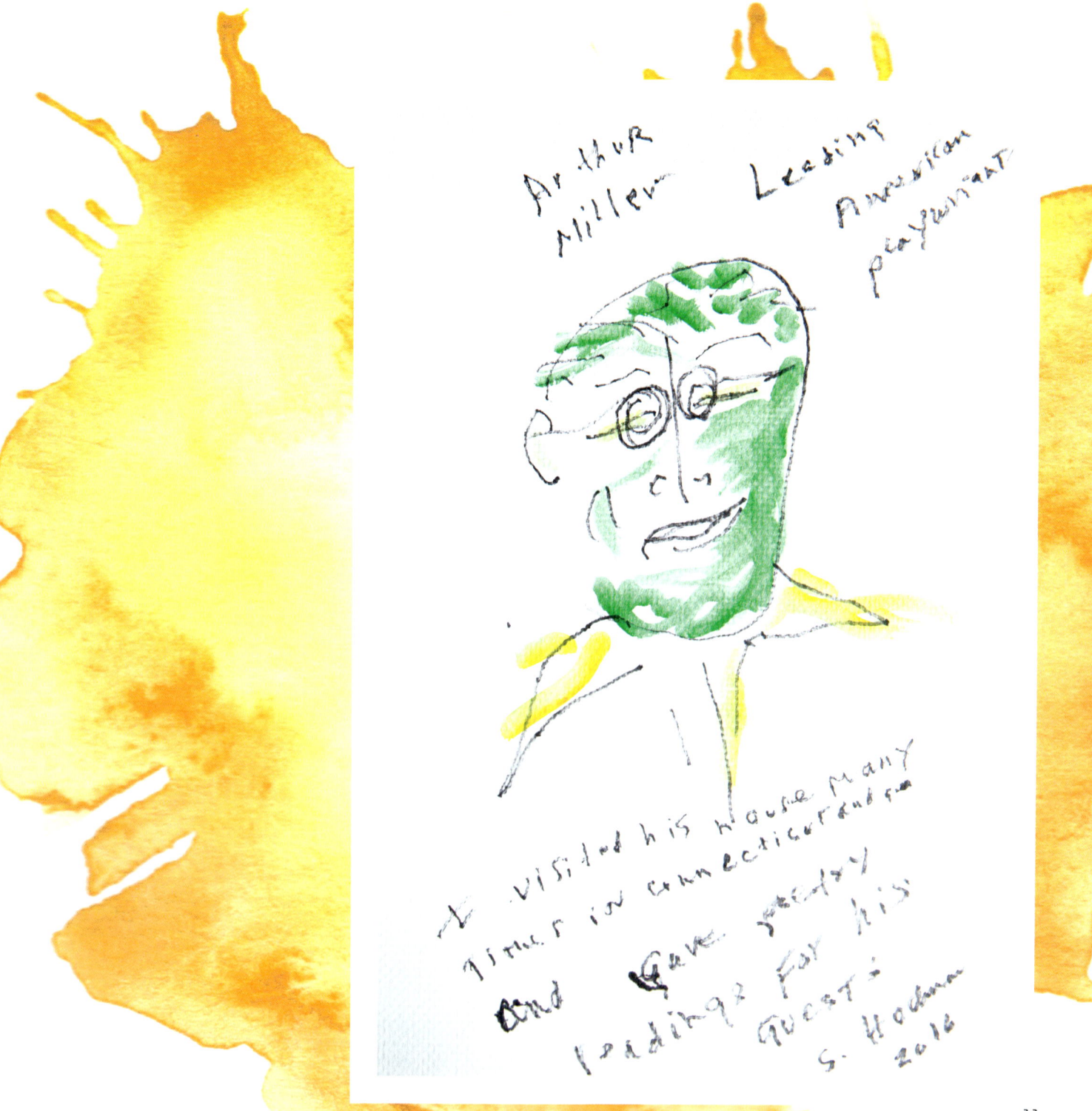

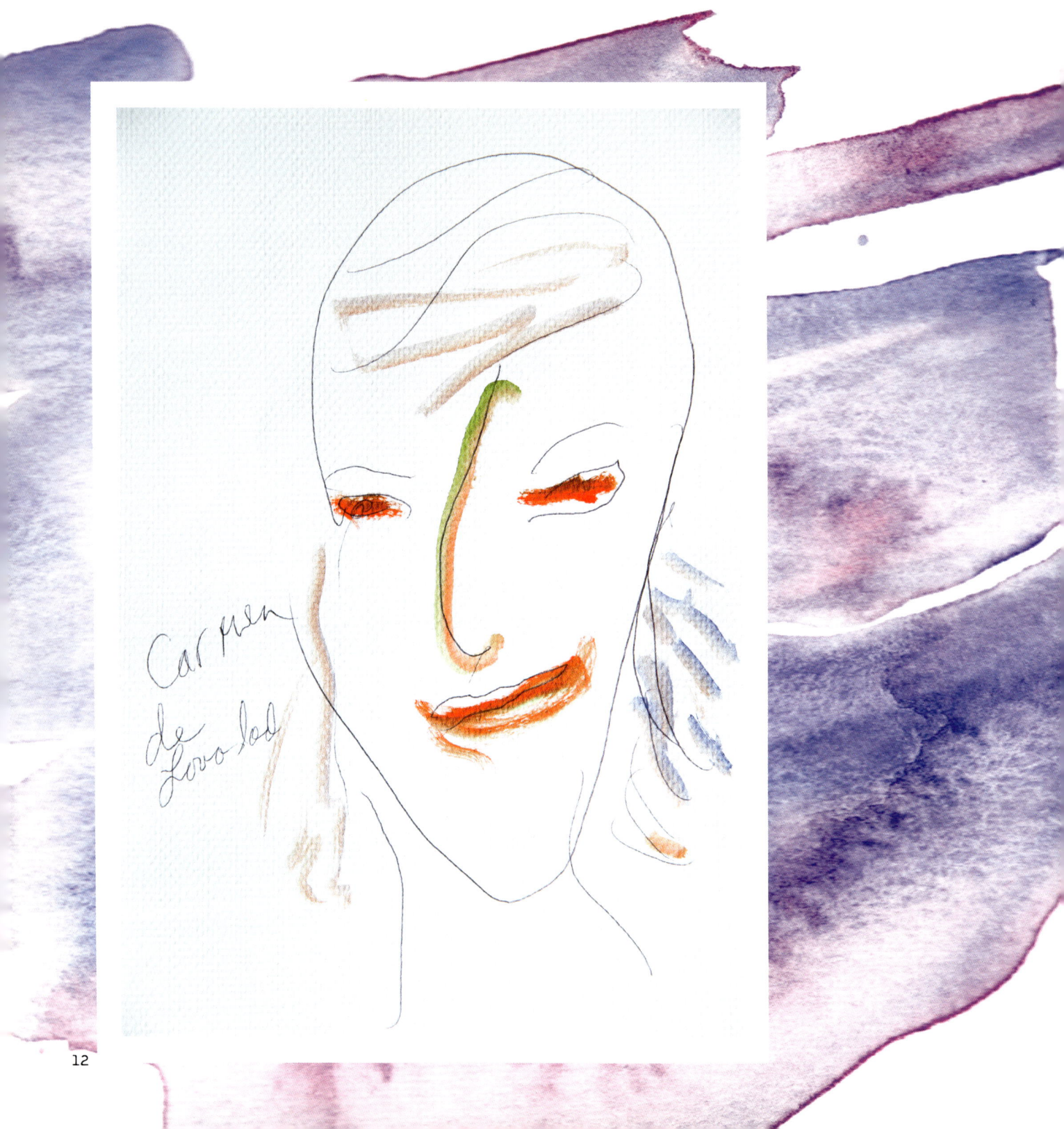

Carmen de Lavallade

March 6, 1931

CARMEN DE LAVALLADE, who was honored at the Kennedy Center in December 2017, was introduced to me by Moni Yakim, the original director of my musical *Rubirosa*. Carmen choreographed *Timmy the Great*, a musical production which I wrote with Gary Kupper. To me, she was always a great Southern lady, with her magnificent clothes sewn and designed by her genius husband, the actor and painter Geoffrey Holder. When Carmen would visit me at my apartment, we would have many great discussions about my ex-boyfriend, Dick Shawn, who attended the Yale School of Drama at the same time Carmen did. Like myself, she greatly admired Dick's talent.

Danny Kaye

January 18, 1911 – March 3, 1987

DANNY KAYE and I met at the party given by my good friend, Marietta Tree. Danny was a comedian and the husband of Sylvia Fine. Sylvia believed that I should be a lyricist like herself.

"How can I be a lyricist out of nowhere?" I asked.

"Send me your poetry," she said.

I sent my poems to her house on San Ysidro Drive in Beverly Hills. A few days later, I received a telegram from Sylvia saying, "Yes, you are a born lyricist." I told her I had admired her husband's talent since I was a child in boarding school. The next thing I knew, I was with Danny and Sylvia as a guest in their home, reading poetry and enjoying Danny's home-cooked Chinese food.

Danny was the star of many films, a great chef, a pilot, and a UNICEF ambassador. It was said that Princess Margaret had a crush on him. So did everyone.

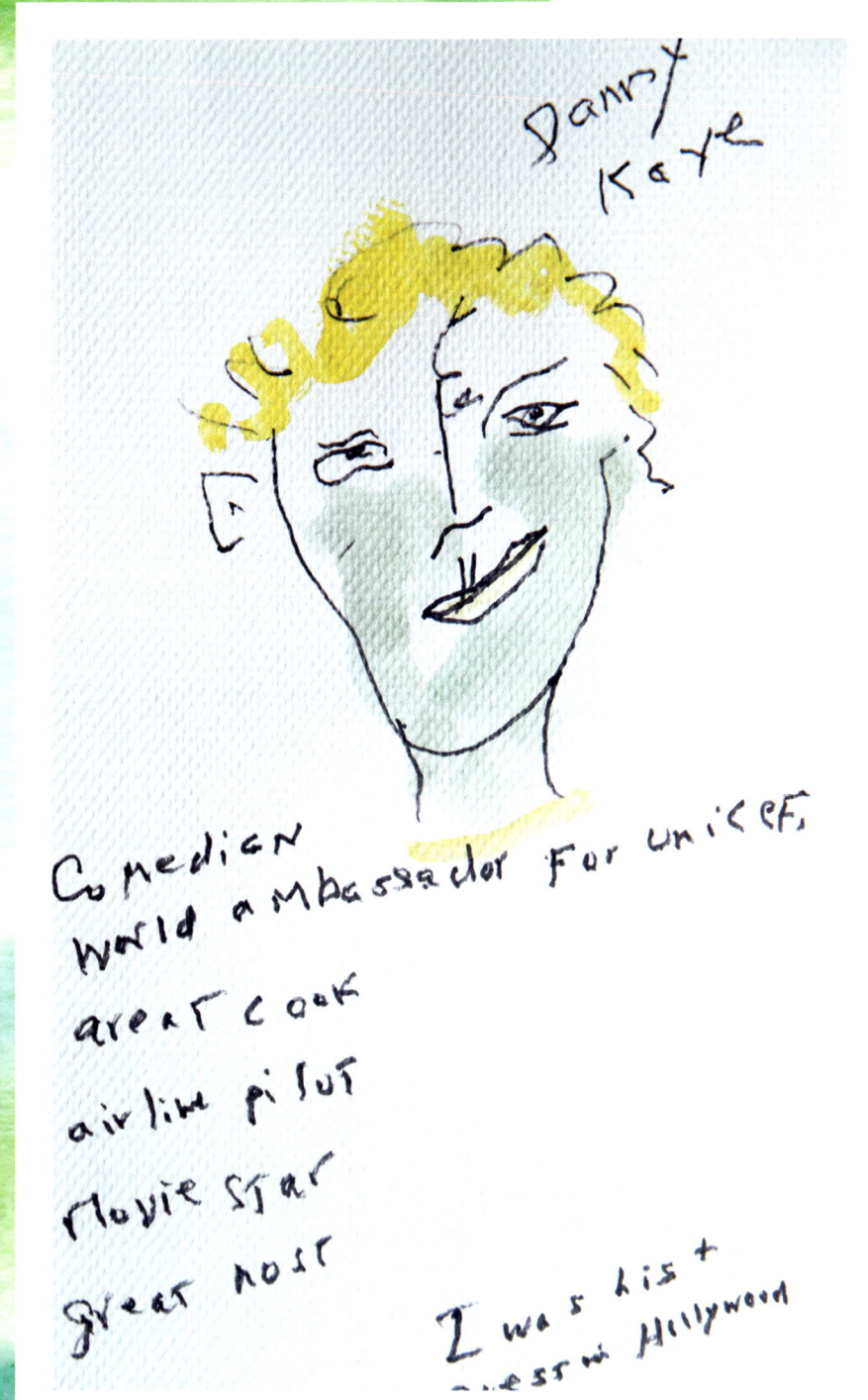

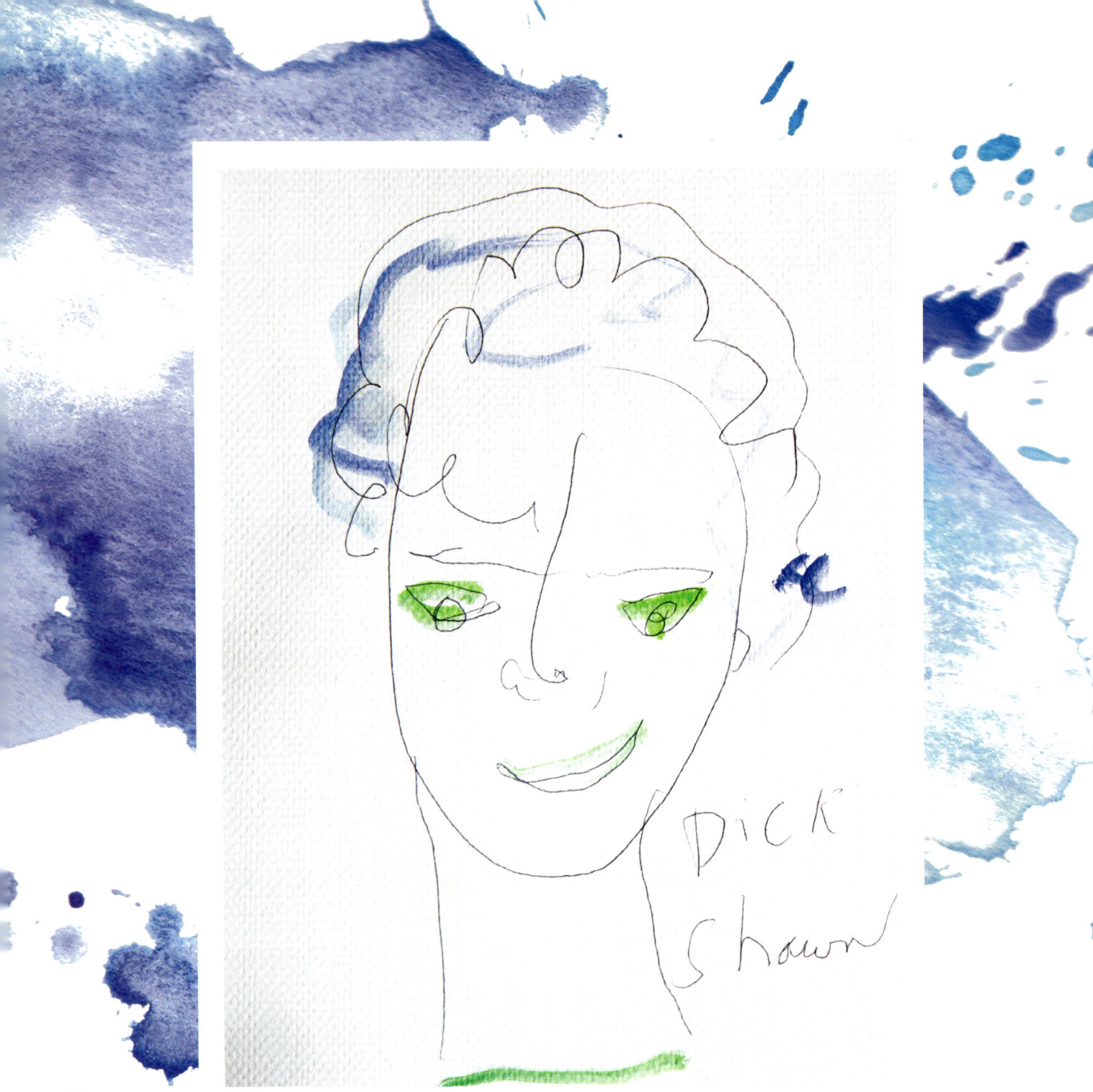

Dick Shawn

December 1, 1923 – April 17, 1987

DICK SHAWN was, I believe, the best American comedian and the greatest love of my life. I was introduced to Dick at the Russian Tea Room by Yip Harburg, who wrote the lyrics for *The Wizard of Oz*. "Now, here's the girl who should write your material, Dick," Yip mentioned.

As it turned out, I did write comic material for him. And after he passed away onstage at a relatively young age, I wrote a book of poems about him called *The Vaudeville Marriage,* which was published by Viking Press, and a play called *The Death of Dick Shawn,* which later became a musical. Dick was a wonderful person to be with because he always kept me laughing.

Dmitri Shostakovich

September 25, 1906 – August 9, 1975

DMITRI SHOSTAKOVICH was one of my favorite composers. I have always been a music lover—thanks to the influence of my mother who took me to concerts and the opera from the time I was three years old. I loved the music of Shostakovich before I could even pronounce his name. Many years later, when I was twenty-one, married to the concert violinist Ivry Gitlis, and living with him in Paris, I was thrilled to meet my childhood hero. We invited Shostakovich to a party at our home and enjoyed each other's company.

Dmitri Shostakovich
Russian Genius

Come to my party in Paris for Oistrak. he stayed the other side of the room from Stravinsky on the other

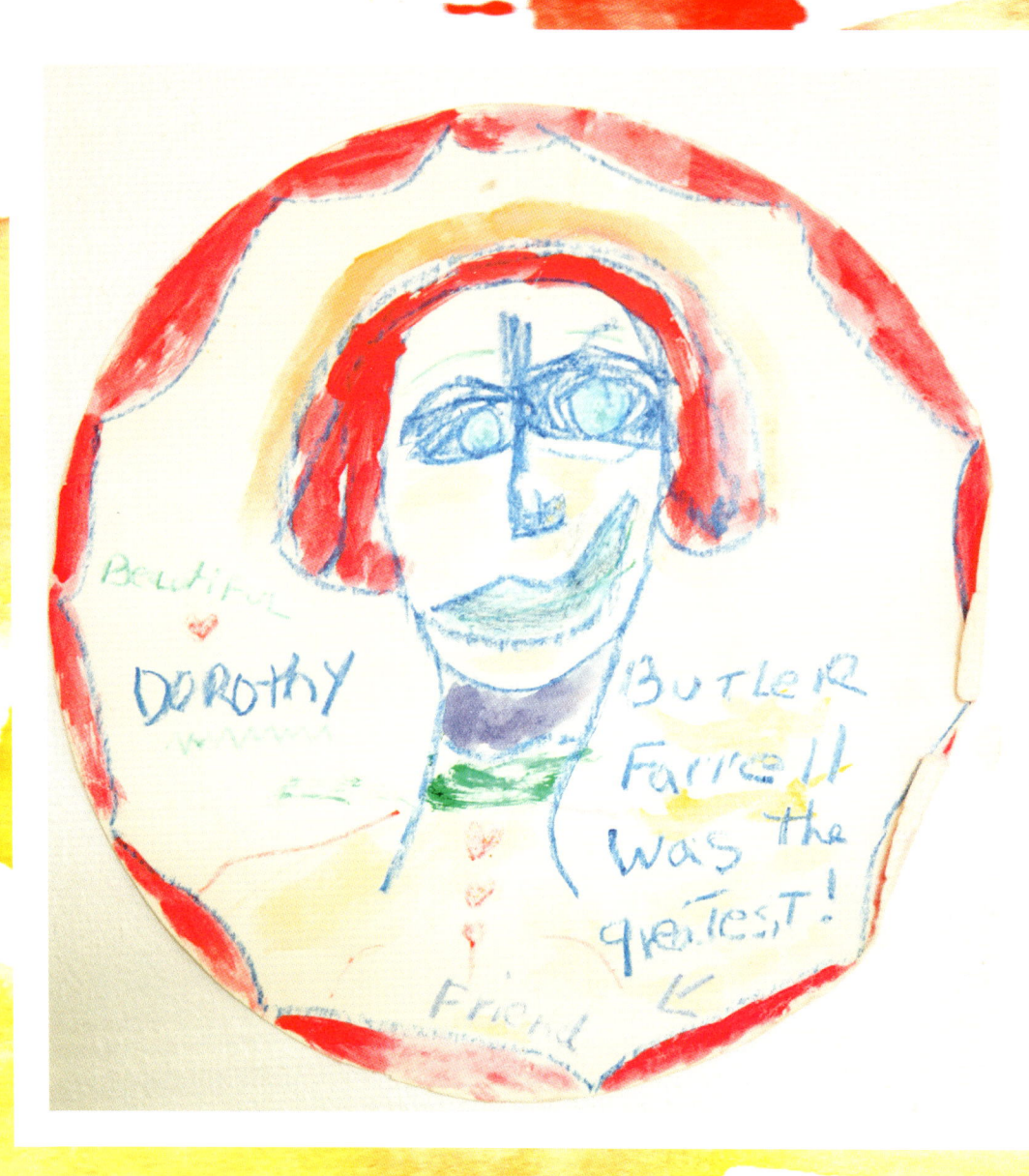

Dorothy Farrell

January 1910 – April 2, 2005

It's hard to write about my friend **DOROTHY BUTLER FARRELL** without crying. I loved her so much. She was the niece of the great Irish poet William Butler Yeats. When she told me he came to visit her and her family in Chicago and read his poems to her, this wildly impressed me, since he was my favorite poet. Besides being the wife of my "patron" James T. Farrell, she was like a second mother. If I ever had to go to the hospital, I would only go with Dorothy. When I was sixteen, I read my poems out loud to a group of people from the transit union, put together by James and Dorothy. I figured if Union people understood my poems, then I'd know everyone else would be receptive. The evening was a triumph for me as well as for James and Dorothy. Dorothy then sent my poetry to Malcolm Cowley, the editor in chief at Viking Press. He sent them back to her, saying "Sorry, Dorothy, Sandra is way too young for Viking to publish."

After I won the Yale Younger Poets award for *Manhattan Pastures*, which was then published by Yale University Press in 1963, Dorothy sent my work back to Mr. Cowley at Viking Press. "Say, Malcolm," she wrote, "what do you think now?" That week I signed a contract with Thomas Guinzburg and Viking Press. They published seven books of my poetry, including *Collected Poems 1960-1970* and my breakthrough novel *Walking Papers*. Thank you, Dorothy, wherever you are in heaven.

Elie Wiesel

September 30, 1928 – July 2, 2016

Meeting **ELIE WIESEL** in 1957 was a thrill. It was the year I graduated from Bennington College and became engaged to my first husband, Ivry Gitlis, who was a Sabra (born in Palestine, now Israel). Wiesel was not only a Holocaust survivor, but was also a journalist and the author of a well-renowned book, *Night,* that showed the world the horrors of the greatest crimes of the Holocaust. When I met Elie Wiesel, he rarely smiled. He had deep circles under his eyes, and was squatting on a cot in the inexpensive Master Apartments on the West Side of New York City. But he did smile when he saw me and Ivry. We had, I remember, a joyful afternoon. Elie went on to become a wealthy global celebrity for his ability to project the horrors of genocide and war.

Elie Weisel
we met in the end sixties he was an Israli Journalist I was a young man, his novels disclose the horrors of the holocaust

Gary Friedman

GARY WILLIAM FRIEDMAN, whom I was introduced to on Fire Island by some mutual friends, took me for a long walk through the fall grass and the sand and told me that he wanted to turn my novel *Walking Papers* into a musical. "It's not hard," he said. "Just take your novel and write the script."

But I wanted to write the songs too. My agent at that time was Leonard Bernstein's sister, who loved my work. She represented Steven Schwartz, the composer of *Godspell* and *Wicked*, among other artists. "It's the songs that make the money. I suggest you write him some dummy lyrics as a sample of what you can do. If he likes them, good. If not, forget it!"

To my surprise, Gary loved my lyrics and set them to music. They were produced in a workshop by Ted Mann (the director and head of the Circle in the Square Theatre). I loved the process. Phyllis Newman portrayed me. The musical was about a woman trying to decide if she should get divorced or stay in a bad marriage. Gary's music was unbelievably moving and suited to my lyrics. Phyllis and her husband, Adolph Green, brought Alan Jay Lerner to the production. I was so thrilled to meet the creator of *My Fair Lady* and other brilliant Broadway musicals. He said, "You and Gary are phenomenal as a team. *Walking Papers* is one of the best musicals I've ever seen."

That phrase went straight to my head. I went on to write *Vaudeville Jive* with Gary. He is truly a genius. Leonard Bernstein told Shirley that Gary was "the best of the new composers." I agree.

Gary William Friedman

Classical & Broadway Composer

The ME NOBODY KNOWS was a brilliant show

It was Gary who got me into writing musicals. We wrote Walking Papers and Vaudeville Jive together

Sandra Hochman
2016

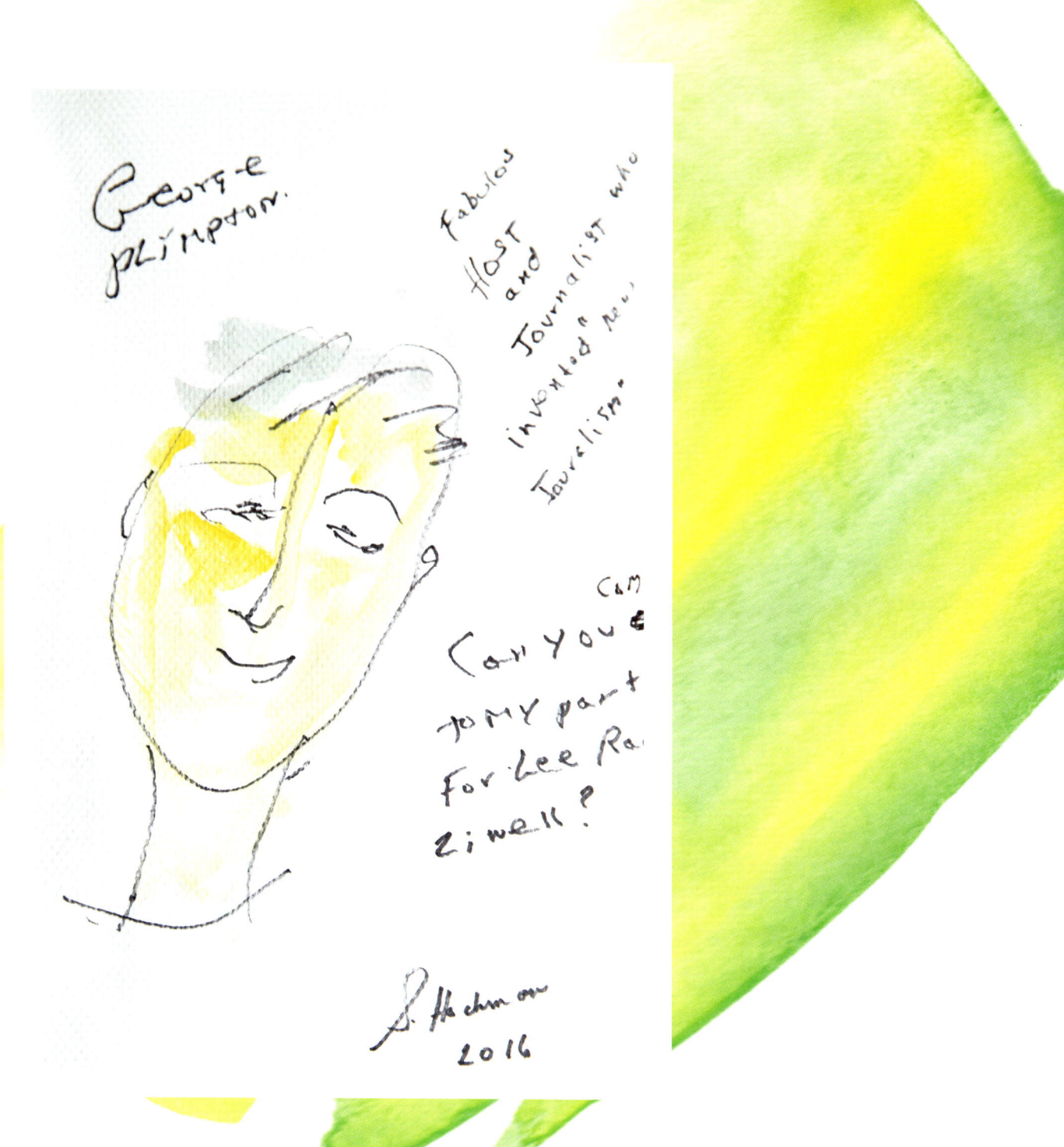

George Plimpton

March 18, 1927 – September 25, 2003

GEORGE PLIMPTON was the most original journalist of the twentieth century. I first met George in Paris when he was the editor in chief for *The Paris Review*. Later on, I was invited to almost all of the parties he would throw at his townhouse on 72nd Street and East River. It was an elegant home which featured a pool table instead of a dining room table. George was never the domestic type, although he did marry his girlfriend, the adorable Freddy, who gave him two children.

Günter Grass

October 16, 1927 – April 13, 2015

In 2007 I was trying to get individuals to see "my papers." Nobody was interested in paying for them except one place: Indiana University. Why? Because the head of the Lilly Library was the new translator of **GÜNTER GRASS**'s masterpiece, *The Tin Drum.*

Günter had put in a good word.

After graduating from college, I developed my own radio show and called it *Power in Print*. Günter had been one of my guests. After the program, we went to lunch with his agent, Nina Korliness. Günter told Nina he wanted me to take his writings and create an evening at the theatre.

I wasn't paid a cent for writing the Broadway production of *The World of Günter Grass*, but I was paid a small fortune for my papers—first drafts of novels, plays, poems, and screenplays, as well as letters from famous celebrities such as Katharine Hepburn, Amber Amour Goldberg, and Leonard Bernstein.

Because of Günter Grass, almost all of my papers were taken out of my storage closet and instead of being thrown out—which was my intention—were sent to the best manuscript library on earth, the same library with the Shakespeare first folio and the papers of Sylvia Plath. The library even threw in a wonderful dinner and devoted a weekend to me, which included a screening of my 1972 documentary *Year of the Woman.*

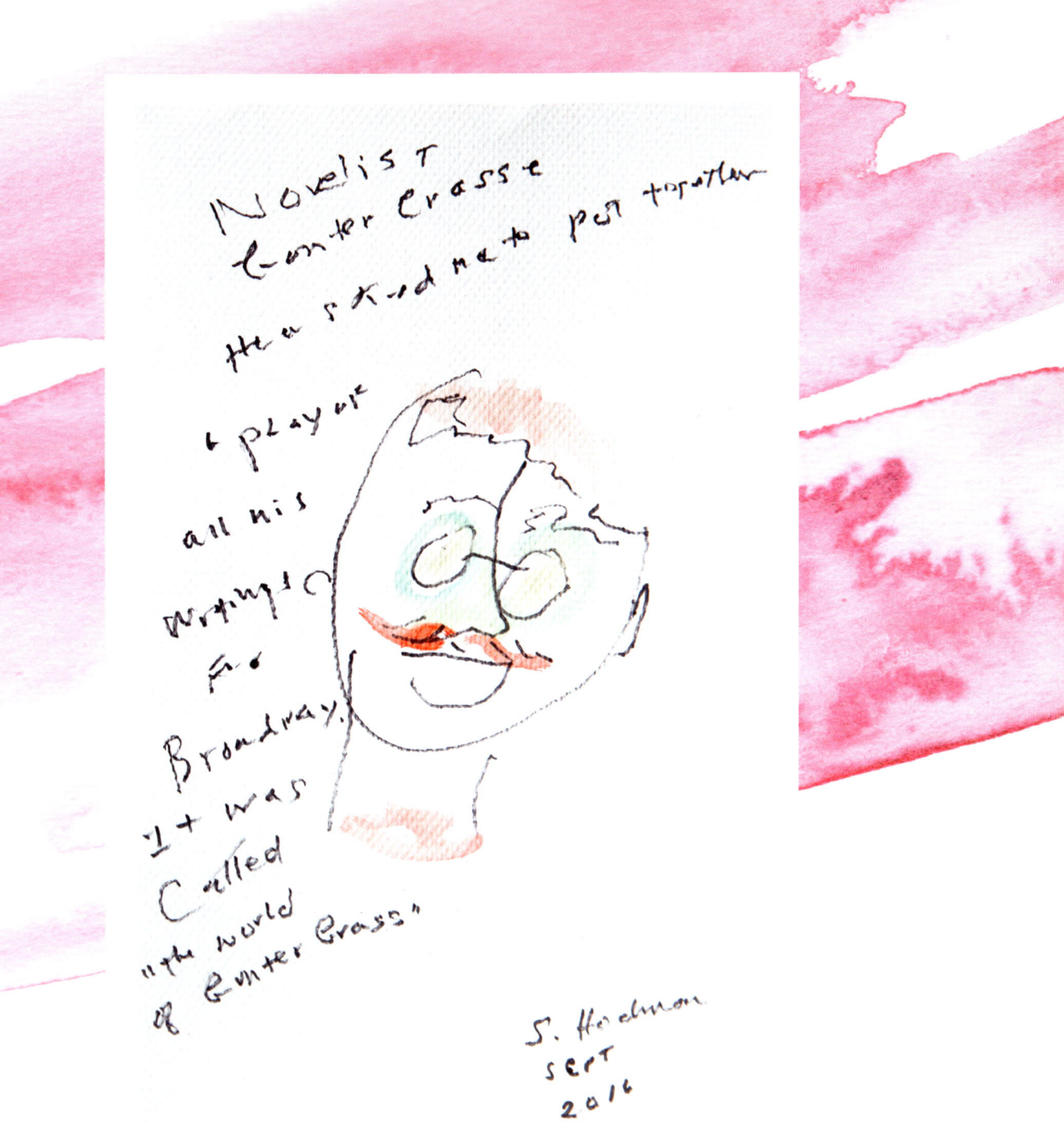

Novelist Günter Grasse
He studied me to put together
a play of
all his
writings
for
Broadway.
It was
called
"the World
of Günter Grass"

S. Hochman
Sept
2016

Harold Nicholas
Tap dancer
extrodinaire
of the
Nicholas
Brothers

His wife asked me to
write a ~~something~~ reply. I did
~~something~~ it was
called "Harold and..."

S.H.
2016

Harold Nicholas

March 27, 1921 – July 3, 2000

A Swedish friend, Marita Gochman, asked if I could write a play about **HAROLD NICHOLAS** of the great Nicholas Brothers. What an honor! I wrote the play, and Ellen Stewart wanted to produce it at La MaMa. But Harold, who was more into golf at that time, objected, and the play *Harold and Me* was never produced. But all was not lost. Out of that experience, I met his wife, Rigmor Newman Nicholas, who is now, and always will be, my best friend.

Harold Robbins

May 21, 1916 – October 14, 1997

According to his lawyer, **HAROLD ROBBINS** sold more books than any writer who ever lived. His Mundy novels were translated into every language and made him very rich and famous. He was also famous for the wild parties at his home in Hollywood and on his enormous yacht, which always docked in Cannes during the film festival. *People* magazine had done a four-page story about me and my novel *Happiness is Too Much Trouble.* They dared me to write an interview on Harold, who never gave interviews. I took the challenge.

I found out when his plane would be landing at LaGuardia. I met the plane. There was Harold in a huge cowboy hat. Harold granted me a two-hour interview at the airport. Before I wrote the article, I found out that all of Harold's books were written at the Hotel Elysée in New York City—the same place Tennessee Williams died with a champagne cork in his mouth. I went to the hotel and interviewed everyone who knew him. I also cajoled his lawyer—who would later become my lawyer and agent—into letting me see some of Harold's early writings. To my amazement, he had written poetry. Really good poetry.

People published the interview. Later, I got a call from Harold's lawyer, thanking me. Harold was overjoyed with the article and wanted to invite me to come on his private yacht during the Cannes festival, which was showing *The Lonely Lady* based on one of Harold's best-selling books. Not wanting to hurt Harold's feelings, I refused on the basis that I never accepted gifts or invitations from the celebrities I interviewed. The truth was, I was not interested in Harold's hedonistic lifestyle, but I was flattered to be invited.

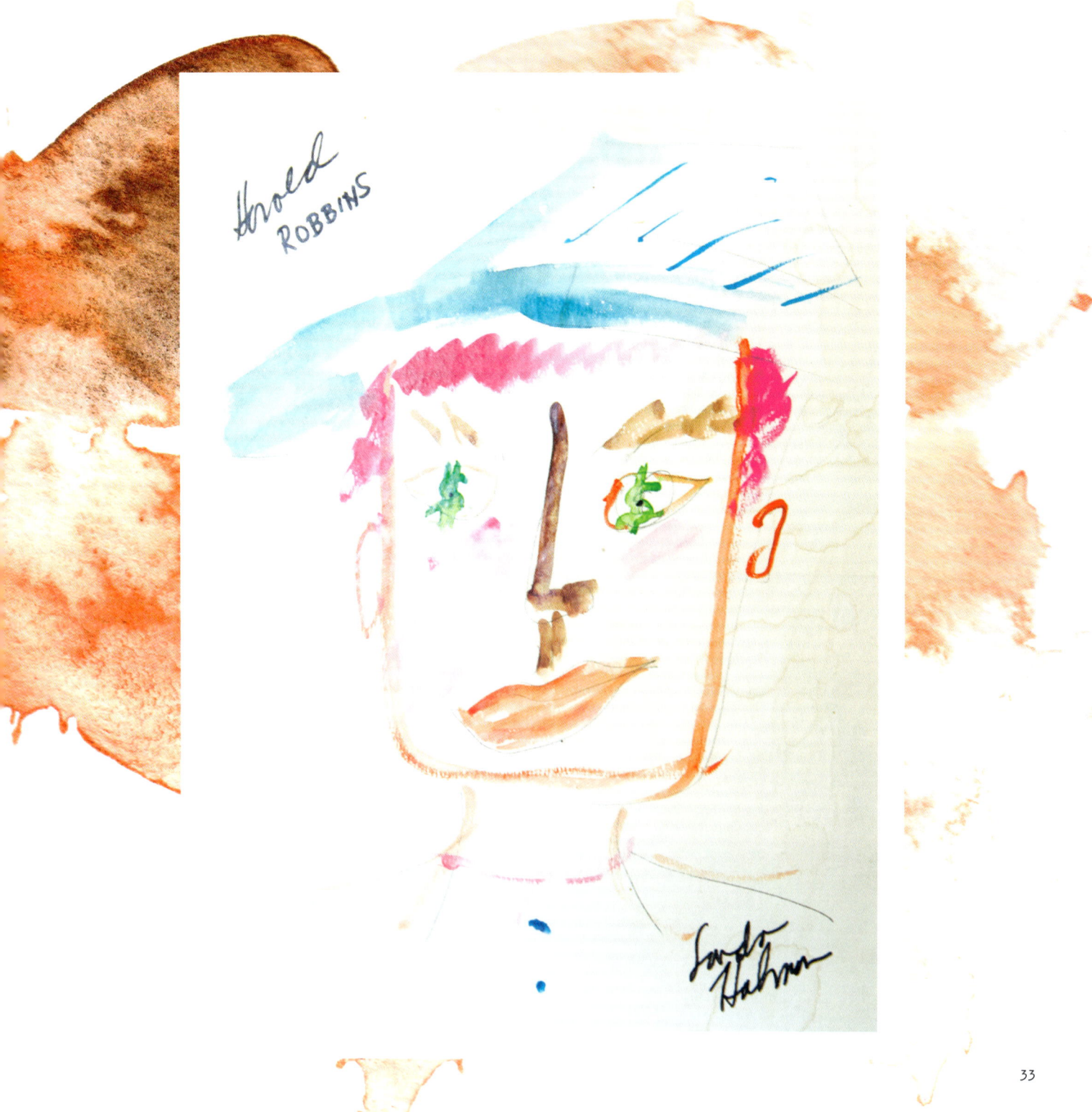

Henry Miller

December 26, 1891 – June 7, 1980

Soon after my daughter, Ariel, was born, I was invited to Hollywood by Danny and Sylvia Kaye to give a poetry reading at an A-list dinner party. I was not thrilled by the A-list in Hollywood. So I called my good friend Anaïs Nin, who lived in Pacific Palisades, and asked if she would introduce me to one of my literary heroes, **HENRY MILLER**. I was supposed to be writing "A Poet's First Impression of Hollywood" for my editor at *The New York Times*, Arthur Gelb. I called Mr. Gelb and asked if instead of writing about the dinner and all the stars that I met, could I change the subject of my article? I said, "I have a better idea. My friend Anaïs Nin is responsible for the fame of Henry Miller, the great novelist. He lives in a secret place and doesn't give interviews because all the interviews after *Tropic of Cancer* were about sex. I want to interview him not about his books but about his watercolors." Arthur liked the idea.

I drove with Anaïs to Henry's house. He couldn't wait to talk about his love for watercolors. He asked me to paint my name on his wall. I did. Then we talked about watercolors for many hours. He said he would trade me two of his watercolors for two of mine. We made the deal. My article was called "The Angel Is My Watermark." When it appeared in *The New York Times*, Henry called me to say how thrilled he was. The article was a full page, and Henry said he was going to have it printed to use as his Christmas card. "You know, Sandra, I keep a Ping-Pong table in my home and when people bore me, as most people do, I play Ping-Pong with them so I don't have to talk. But my darling, I would never have to play Ping-Pong with you." What a compliment coming from a genius like Henry Miller.

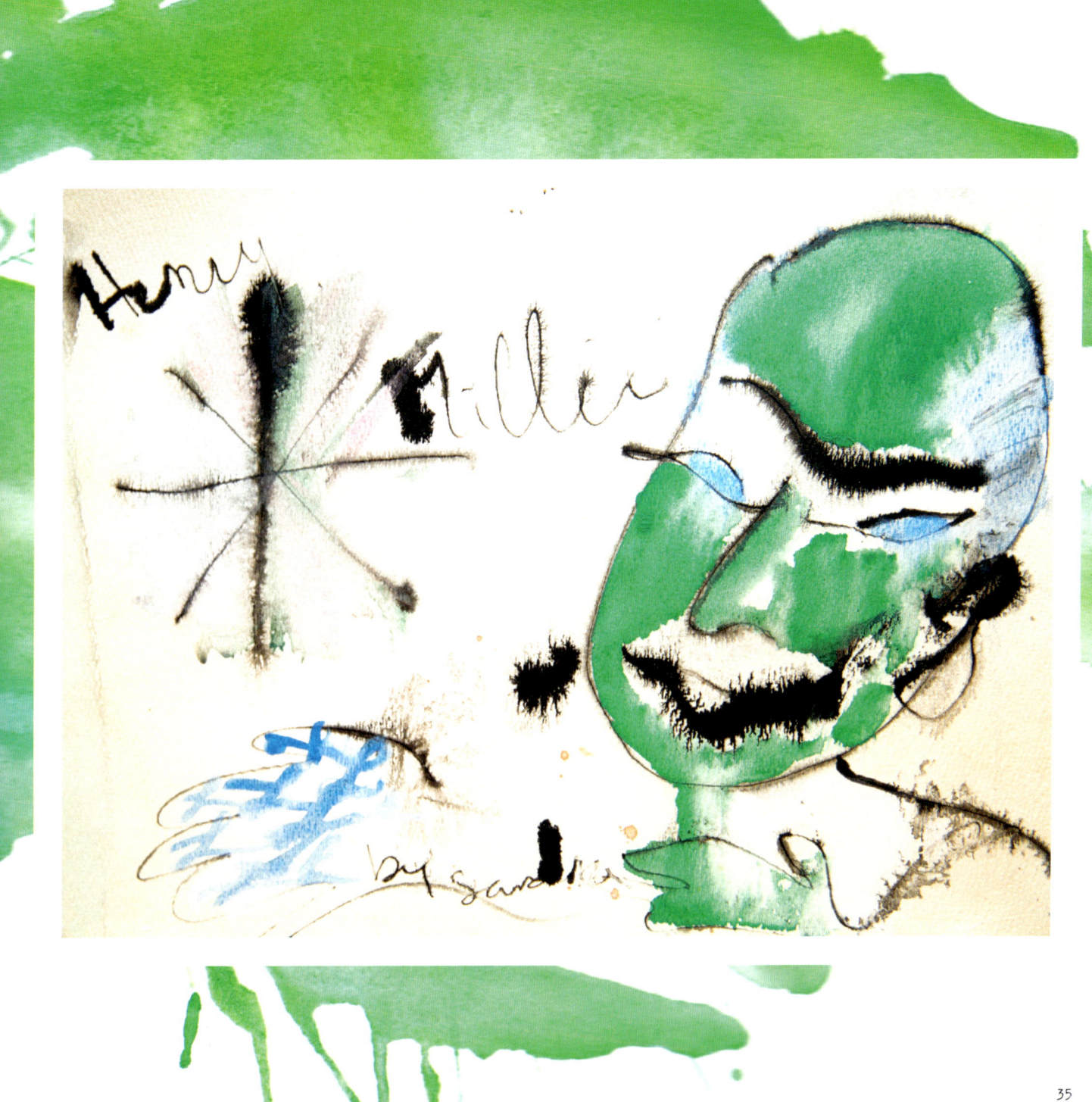

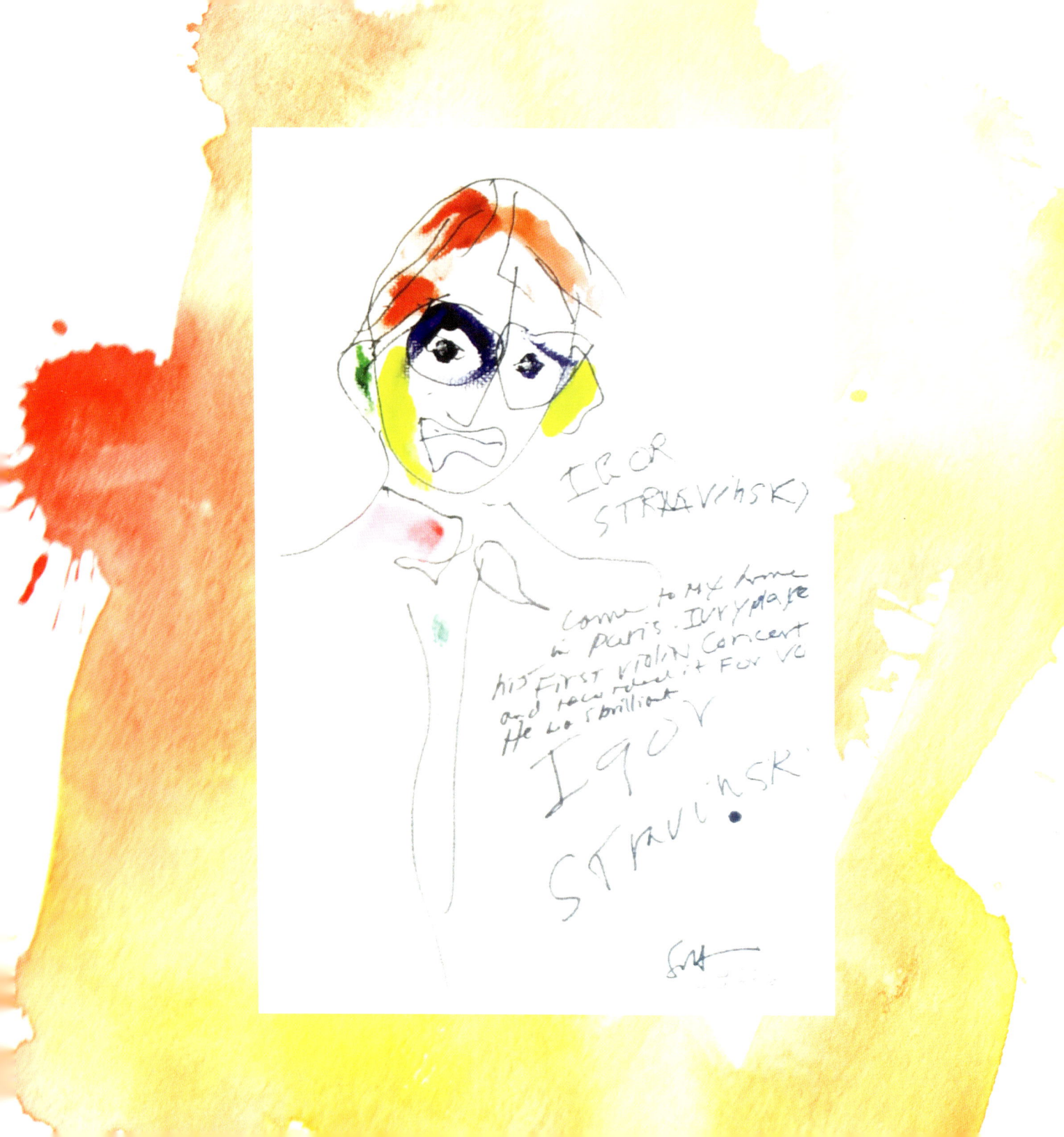

Igor Stravinsky

June 17, 1882 – April 6, 1971

Oh wonderful **IGOR STRAVINSKY,** my favorite composer. He came to a party I gave with my first husband, Ivry, in Paris. Ivry had made the first recording of Igor's violin concerto for Vox records. Igor told everyone in the classical music world that the recording was "a masterpiece." Having fled communist Russia when he was very young, Igor adored being in Paris, and everyone in Paris adored him. This was especially true after the huge success of Serge Diaghilev's great Ballet Russes company which featured the dancer Nijinsky and had sets by Picasso and featured Igor's music. In Paris, as well as all over the world, he was one of the great celebrities that everyone wanted to meet.

Ivry Gitlis

August 25, 1922

I met the concert violinist **IVRY GITLIS** when I was nineteen and attending Bennington College. I fell in love with his music, and he said he fell in love with my poetry. We were married in 1958 at the top of Mount Carmel in Israel, where Ivry was born. Because I was married to Ivry, whose home was in Paris, I met many celebrities in the art and music world of Paris. Our marriage lasted four years. I left Ivry because being second fiddle to his career wasn't much fun, and after touring all over Europe, I wanted to settle down and have children. Even after our marriage failed, we remained good friends.

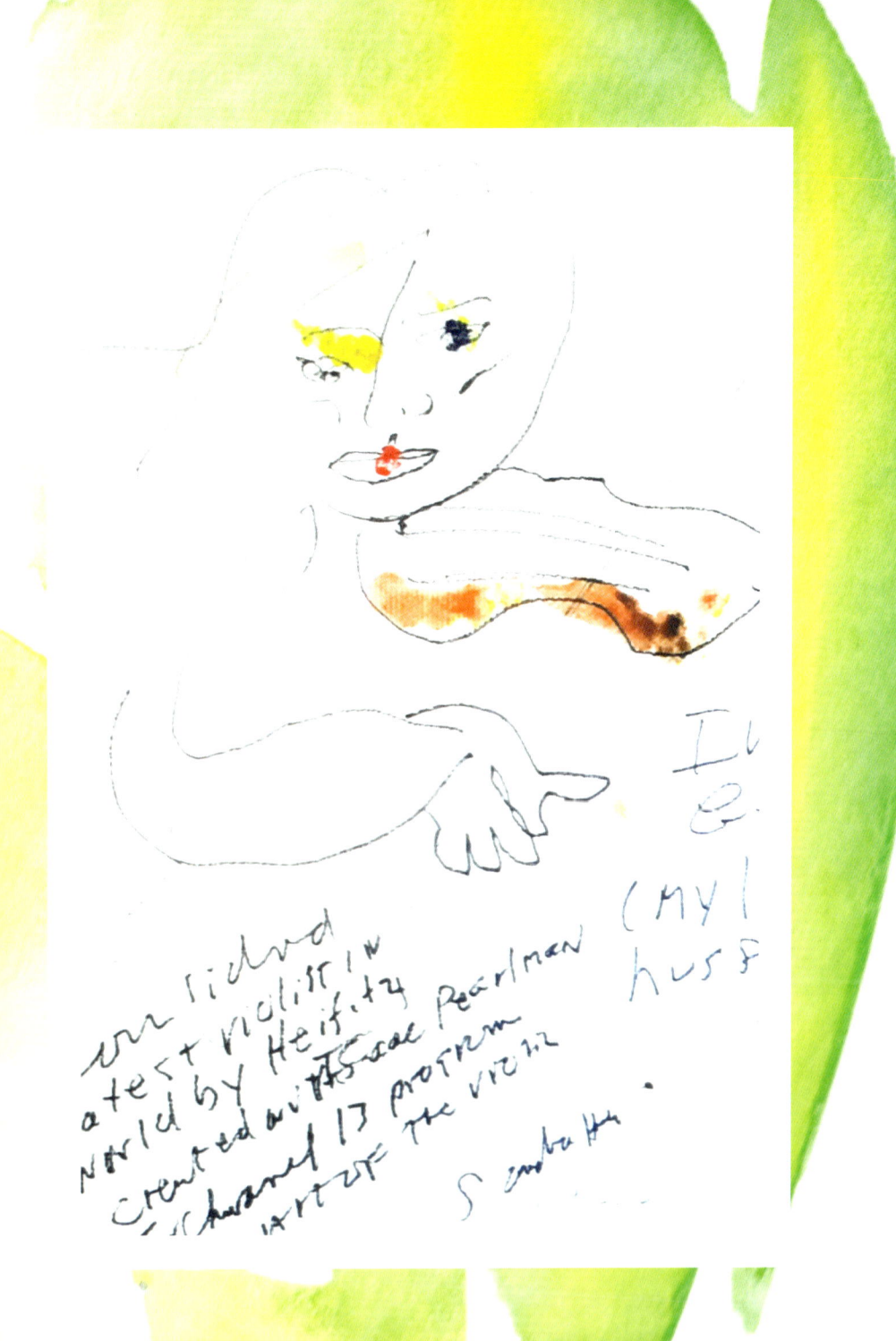

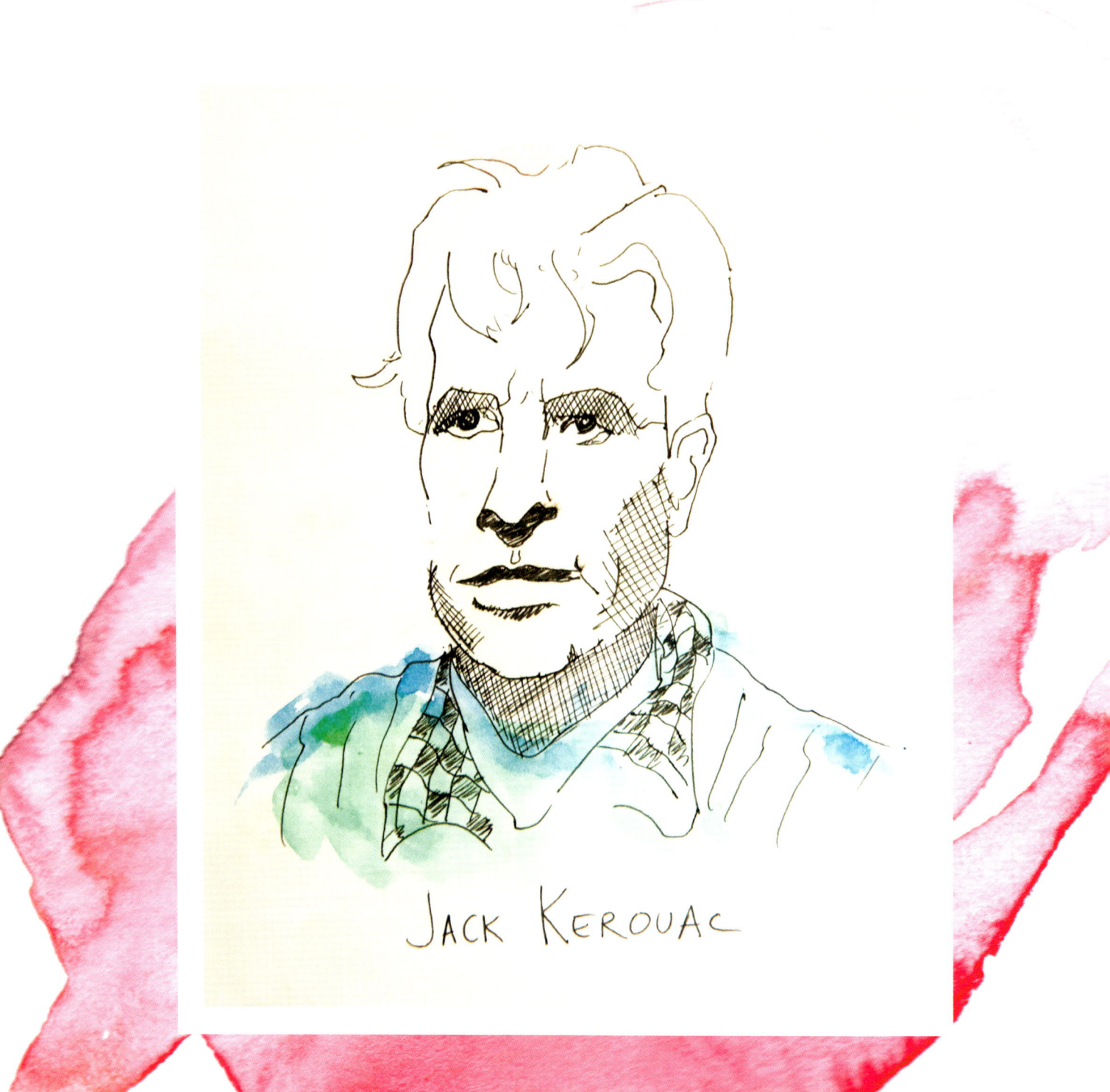

Jack Kerouac

March 12, 1922 – October 21, 1969

JACK KEROUAC was the James Joyce of American literature; his novel *On the Road* changed fiction for all time. I met him when I was working for Grove Press, as an assistant for the *Evergreen Review*. He came to the office with Allen Ginsberg. He was so handsome in his leather jacket, and I blushed when he talked to me and invited me to lunch. I was seventeen at the time and was very shy, and I turned down the opportunity because I was afraid I wouldn't have anything to say to the two biggest literary stars of the beatnik movement.

James Baldwin

August 2, 1924 – December 1, 1987

JAMES BALDWIN played an important role in my life. He took me into the private world of his family. I visited him in Harlem as well as in Hollywood, where he was employed to make a film (which never got made). His essay "The Fire Next Time," which appeared in *The New Yorker* amongst advertisements for liquor and every product under the sun, burned through the souls of white people and African Americans. It was confessional and angry. It wasn't easy to be a writer in America, it wasn't easy to be African American, and it wasn't easy to be gay. Jimmy, who was all three, moved to Saint-Paul de Vence in France and did some of his best writing there. He finally felt at home. When we first met at the actors studio, he invited me to his home. He gave me his magical novel *Giovanni's Room* and wrote inside the book:

To Sandra,

Go the distance. It's not how you start, it's how you finish.

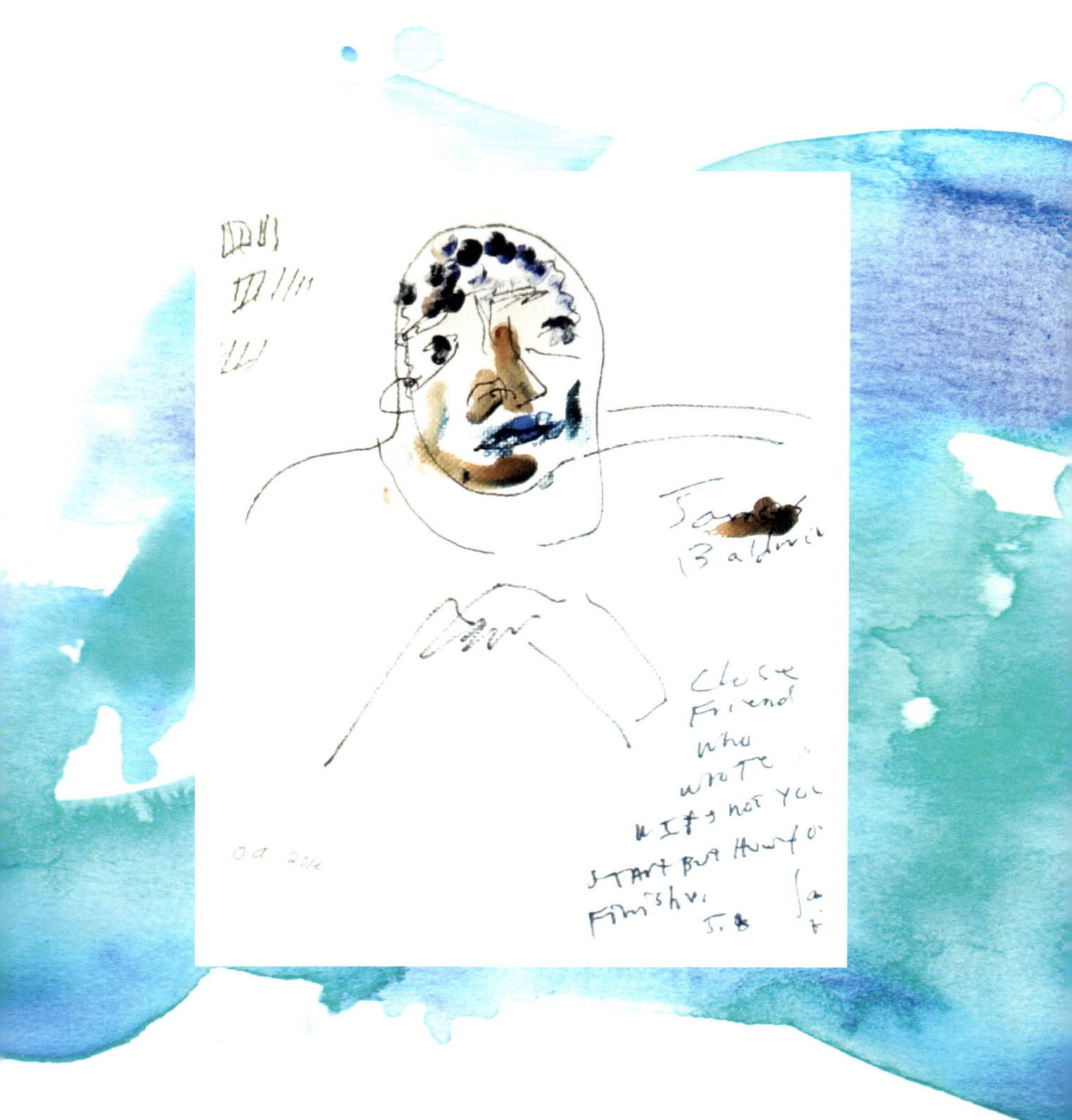

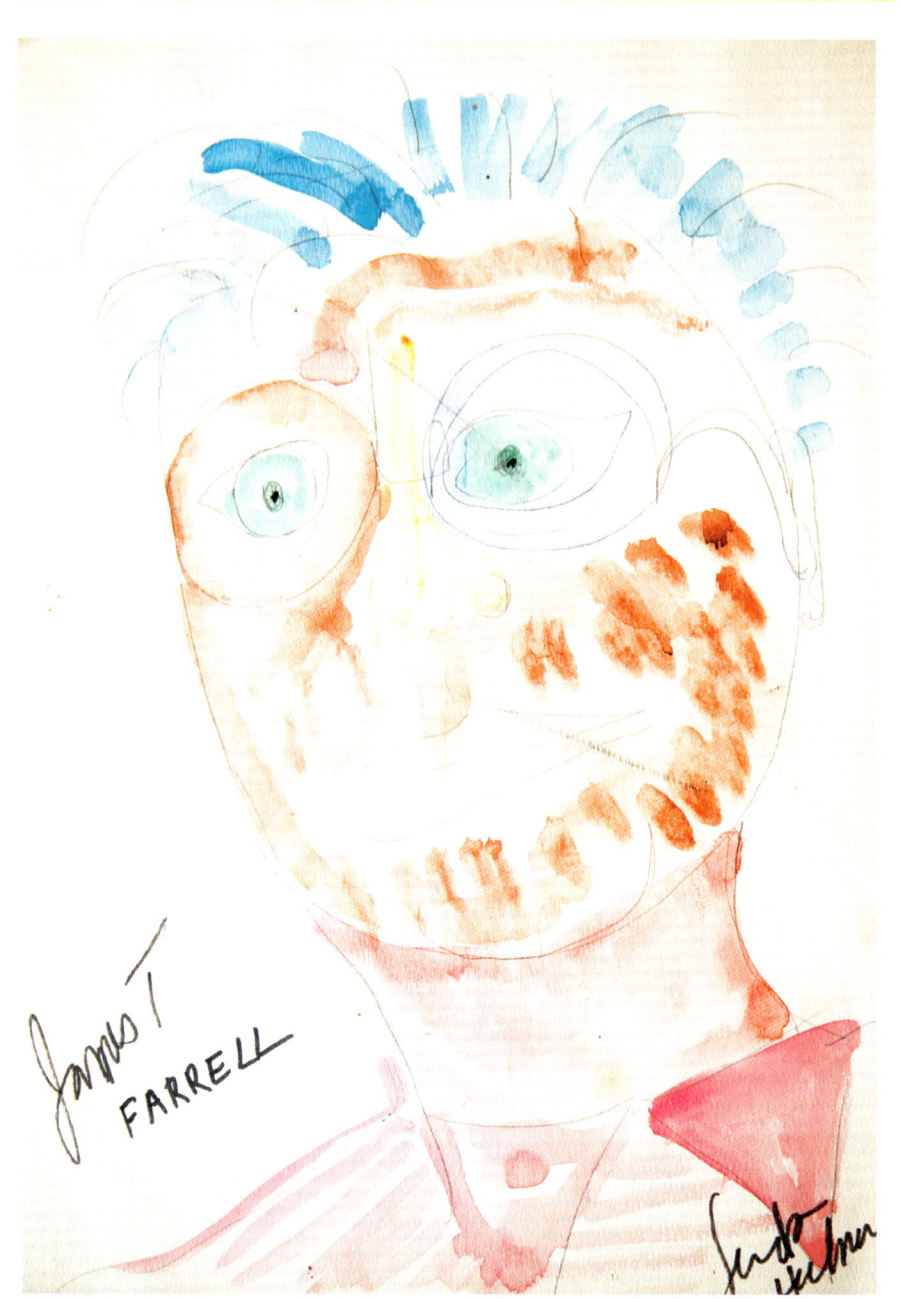

James T. Farrell

February 27, 1904 – August 22, 1979

I met **JAMES T. FARRELL** when he was out of fashion, drinking himself to death, and living in the Dryden East Hotel. The Dryden East was a residential hotel on East 39th Street; the lobby was decorated by Dorothy Draper. However, it was another Dorothy who saved James's life—his ex-wife Dorothy Butler, whom he remarried and lived with for many happy years. Dorothy and James were my literary parents. We remained good friends until the end of his life. In 2004, I went to a big ceremony honoring the one hundredth birthday of James T. Farrell at the public library. Norman Mailer, Pete Hamill, and many others spoke about the influence Farrell's writing, especially *Studs Lonigan,* had upon their own writing. Recently, I was amazed to find out that our written correspondence is preserved in the Newberry Library in Chicago. Today, James is recognized as a realistic writer in the same class as Theodore Dreiser, and President Kennedy once told me that James was his favorite writer.

John Cage

September 5, 1912 – August 12, 1992

JOHN CAGE was a fabulous twelve-tone musician, a magnificent writer, and a good friend. His book *Silence* is so wonderful. After my father passed away, I gave a lot of parties, and John was always in attendance. I'll never forget the laughter of John Cage, as it brought sunlight into every place that he went.

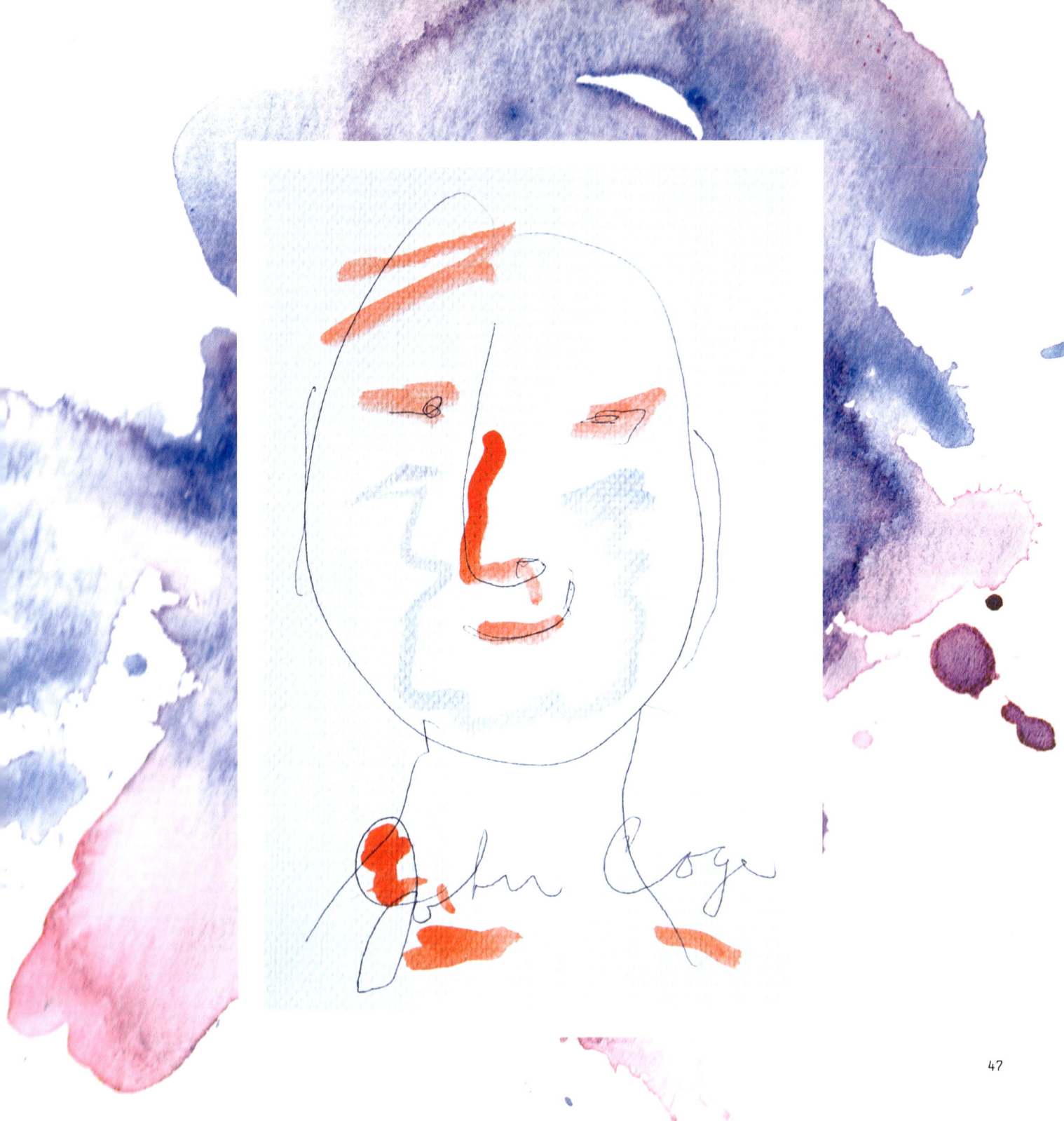

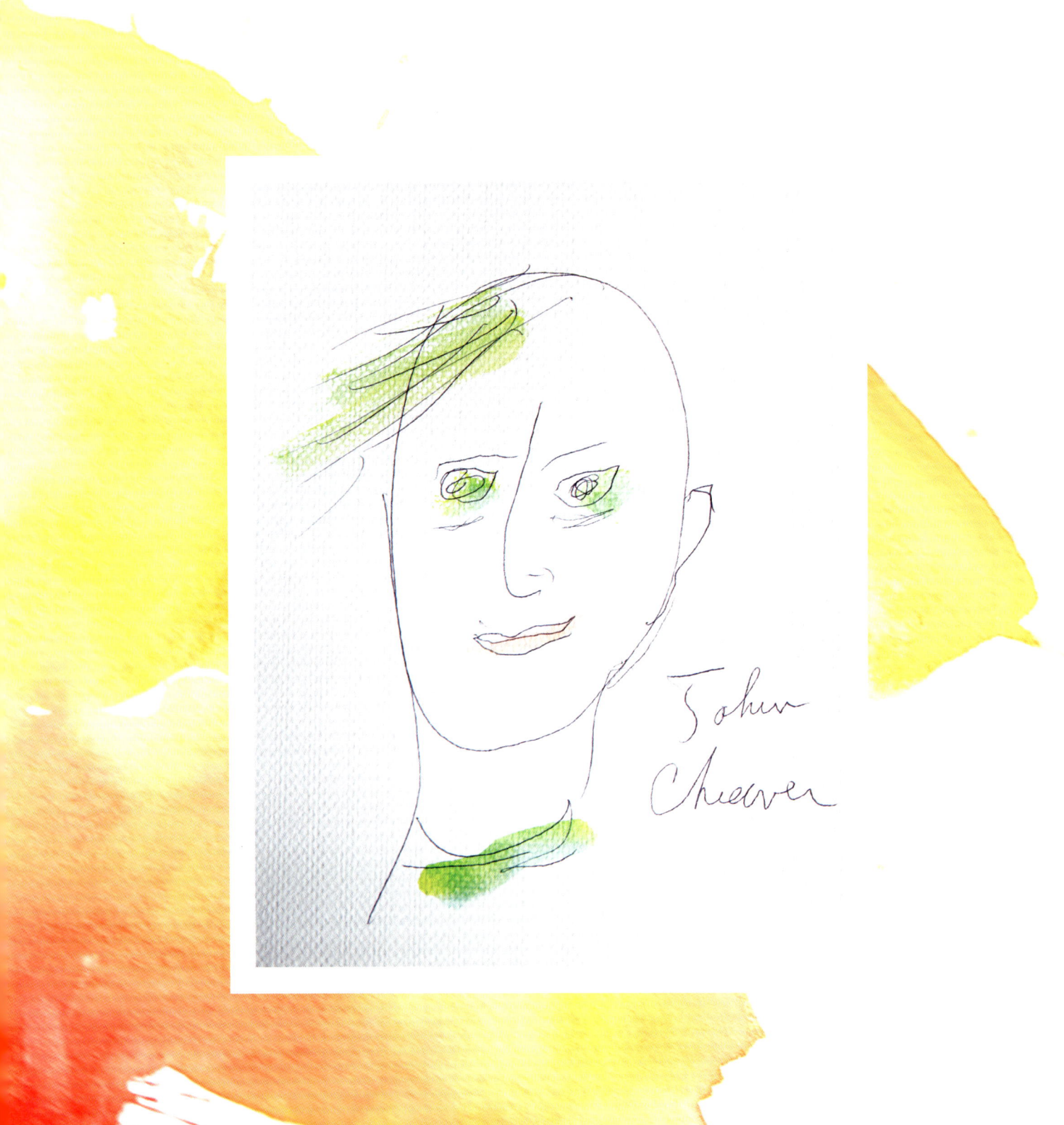

John Cheever

May 27, 1912 – June 18, 1982

I met **JOHN CHEEVER** at a pool party given by my father's good friend Saratt Spence. This was the pool that he wrote about in his brilliant short story *The Swimmer.* "Congratulations, Sandra, you are now my favorite poet," he said upon meeting me. I had no idea how he had found my poetry, as I had only a slim volume, *Voyage Home*, published in Paris. "How did you find my poetry?" I asked. "Dudley Fitts, the editor of the Yale Series of Younger Poets, just showed me parts of your book *Manhattan Pastures*. Will you come and sign it for me?" I was very young at that time. I had recently given birth to a little girl, and I decided, along with her father, that we would spend our summers together with the Cheevers. John and Mary Cheever became our neighbors, and that was the beginning of a close friendship which lasted until John died.

Jules Feiffer

January 26, 1929

JULES FEIFFER was one of the most famous cartoonists for *The Village Voice* during the Vietnam War and afterwards. He was also a great playwright and the screenwriter of *Carnal Knowledge*. While I was writing the biography section for *People* magazine, I was given a list of all the people who didn't want to be interviewed. I managed to convince all of them that I was a poet, which to their minds sounded harmless. With Jules, I promised him I would let him see the interview before it was published to make sure that he approved. This was against the rules, but I didn't care. I know how sensitive every artist is about bad publicity. Jules was working on a play in New York and he didn't like the director. He asked me to not write about that, and I promised that I would not put that in the interview. Before the article was published, I called my editor at *People* and asked him to read me the interview before the issue went to press. I listened in horror, as *People* had dug up the dirt about Jules's tiff with the director.

"Take that out! I didn't write that, and the interview has my name on it!" The editor refused to delete the unflattering information I had promised Jules would not be mentioned in the interview. When they refused to delete that unnecessary information, I said, "Take my name off the article." I never wrote for *People* again. Thank God, Jules loved me. I don't break promises, at least promises I make to great artists.

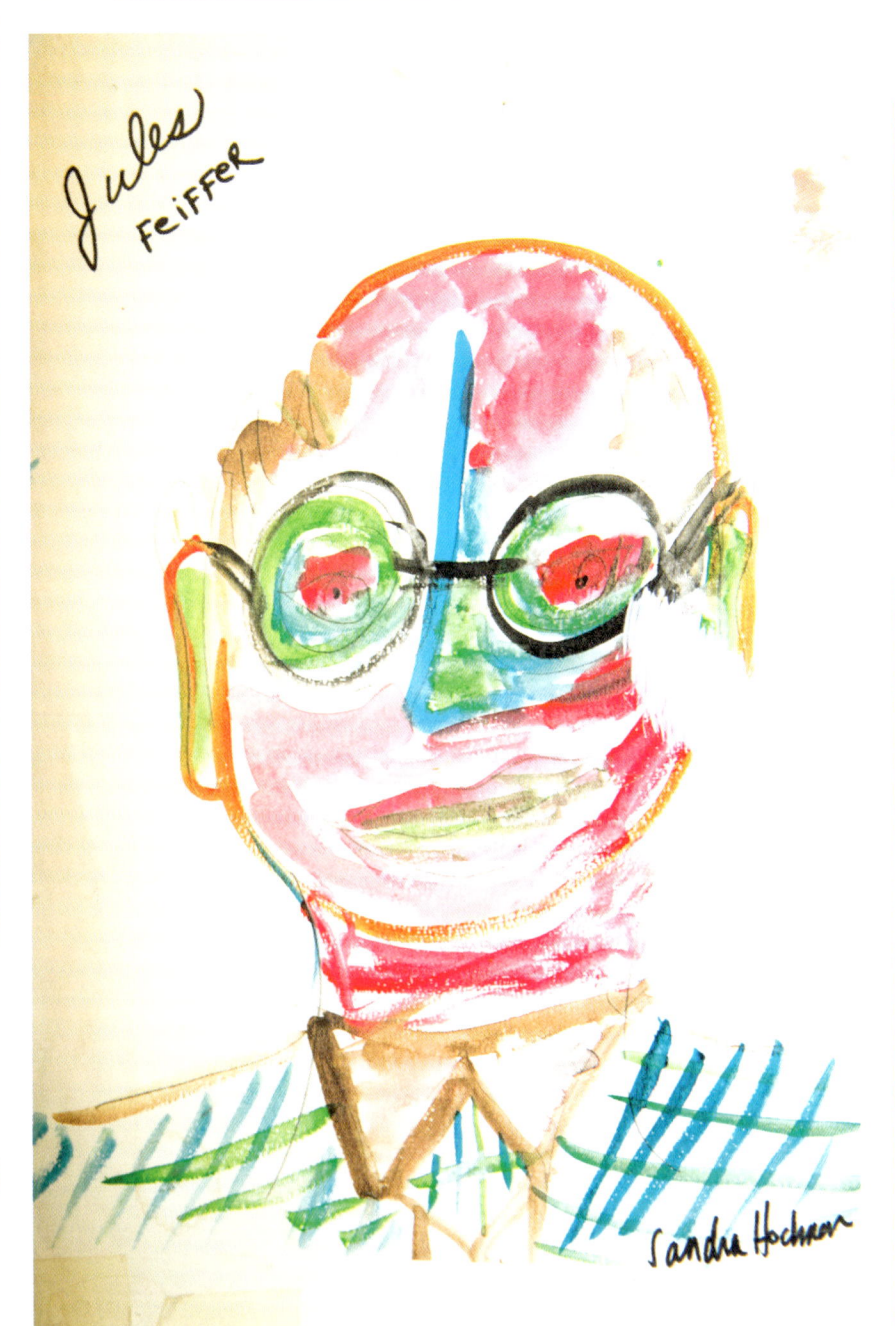

Julie Arenal

College friend + Choreographer +
co-director + Choreographer of HAIR
on the Street of TMM
My children
named to greet
1 Andrew

Julie Arenal

JULIE ARENAL and I both were students living in Franklin house at Bennington College. That was the house for intellectuals. I loved Julie. She became a choreographer, and I became a poet. Julie choreographed the original production *Hair*. In 2016, Julie codirected a musical that I wrote with the wonderfully talented composer Gary Kupper called *Timmy the Great*. Julie was the choreographer as well. She had also choreographed another musical I wrote with Gary called *Rubirosa*. Everything Julie does is original and very beautiful. I feel lucky to have her as a friend.

Larry Rivers was
my favorite

American
painter & jazz
artist who came
to my house for dinner Mott
dinner with Barbara and
& Sheldon Harnick and
his wife Margie & TAD
Daniel G. Hedeman
2018

Larry Rivers

August 17, 1923 – August 14, 2002

LARRY RIVERS was one of America's most original painters. He was also a jazz musician and a crazy guy, but crazy in a beautiful way. He once came to a dinner at my apartment, which I gave because my friend Sheldon Harnick's wife, Margie, was a painter and I thought she would like to meet Larry. I sat between Larry and Sheldon and thought, "My god, I'm squished between two authentic geniuses." Larry's work, for a time, was shown at the gallery of John Meyers. I went on several dates with Larry. He was so goofy and so talented and we always had a lot of fun.

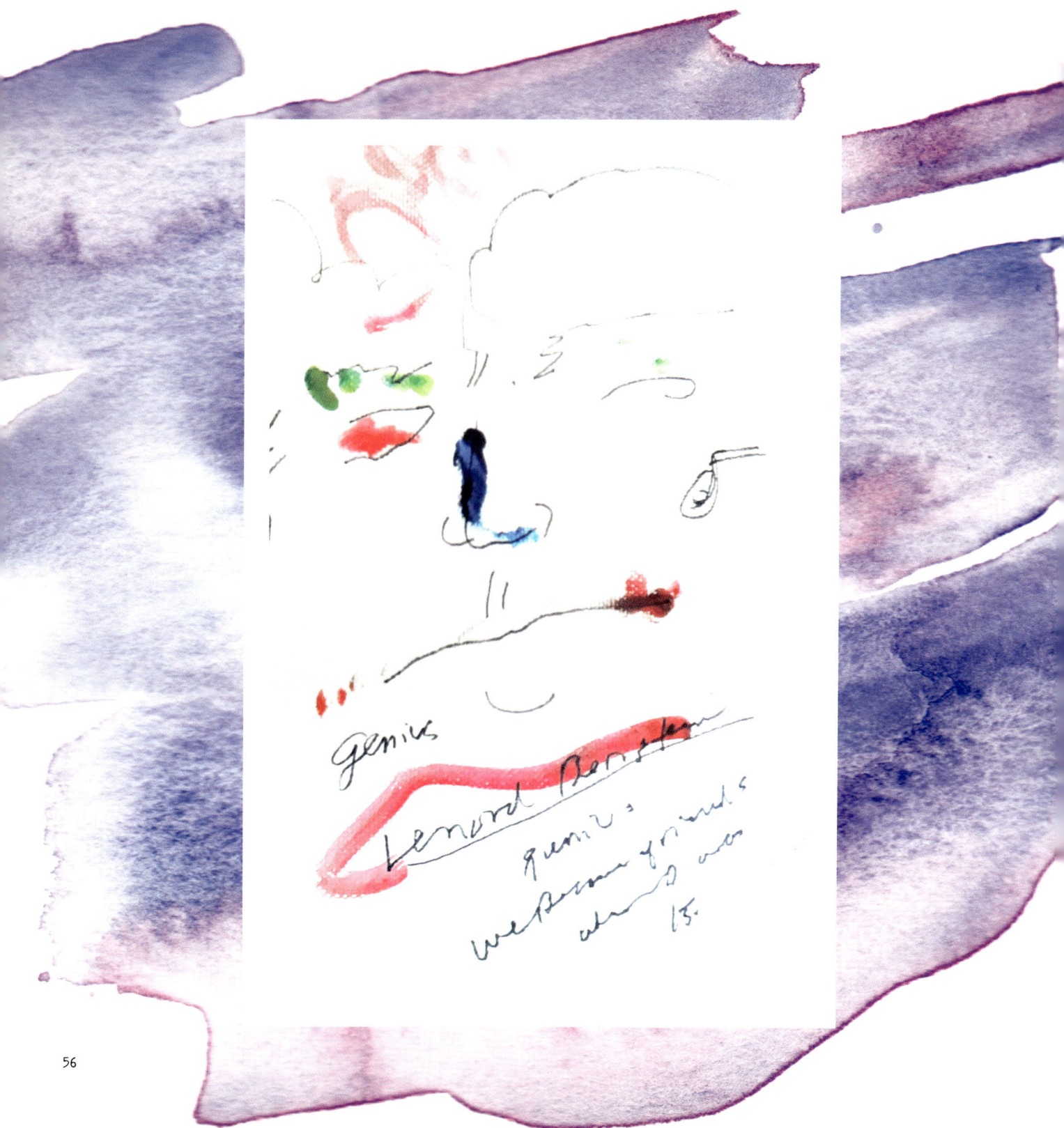

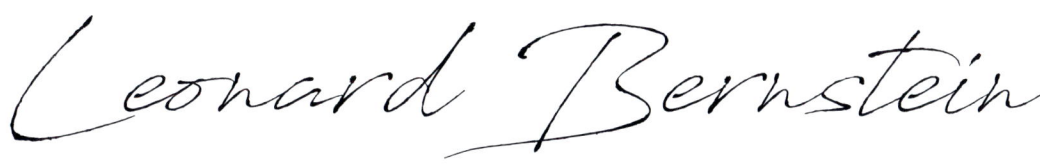

Leonard Bernstein

August 25, 1918 – October 14, 1990

I met the great **LEONARD BERNSTEIN** when I was fifteen and going to an arts camp called Beaupre in Lenox, Massachusetts. I shook hands with Lenny many times after outdoor concerts, but I was eager to really talk with him because I knew he was brilliant. So I invented a newspaper called *The Beaupre News*. I knew that he and his fiancée, Felicia Montealegra, were living at Blantyre, the palatial hotel in Lenox. I though of calling him and asking for an interview, but I was afraid that my voice sounded too young. I asked Ethel Gohesman, who was nineteen and a freshman at Wheaton College, to make the call with her "grown-up voice." I almost fainted when Ethel told me he said yes, and he was granting me an interview the following Monday at 3 P.M.

He and his fiancée couldn't have been nicer to me. I asked Lenny a lot of questions about his life. I had done my homework and knew the answers to most of my questions. During our interview, he asked questions about my life in the sweetest way imaginable. I had told him that I was starting Bennington College the following year and wasn't sure if I wanted to pursue the acting career path or writing. He advised that when I attend college I should take courses I know nothing about. That way I would really learn something.

It was great advice and I took it. I studied biology and labor problems. Many years later, I met him again, and we became friends because my husband was a star in the music world.

Lenny wrote me a beautiful letter when Ariel was born, quoting one of my favorite poems. I never told him that I faked *The Beaupre News*.

Marcel Marceau

March 22, 1923 – September 22, 2007

When we lived in Paris, **MARCEL MARCEAU** was one of my husband's best friends. His real name was Mangel and he was Jewish. He had hidden during the Second World War in the south of France. Marcel had studied mime with his master, Etienne Decroux, and then made the ancient art of mime popular all over the world.

Marcel came into our living room when we lived in a huge apartment on the Rue de Bac. He amazed Ivry and myself by performing *Le Manteau*, based on the short story by the great Russian writer Gogol. At the end of this performance, we were both crying. It was a masterpiece of silence and theater.

One day, Marcel asked me if I would like to study with him. I had been a professional actress in New York City, performing at the age of nineteen with great actors at the Circle in the Square Theatre on Bleecker Street which had helped build the reputation of "Off Broadway" thanks to José Quintero and Ted Mann. I appeared as one of the three whores in Eugene O'Neill's *The Iceman Cometh*.

Moving to Paris made me sad in some ways because I not only missed my actor friends in New York, but also my French was not good enough for me to try out for any productions. I therefore loved mime, and Marceau was more than kind. He was very encouraging as I performed exercises at the Théâtre de l'Ambigu, where he performed and taught his "star student" Moni Yakim, who is now the the director of movement for the drama department at the prestigious Juilliard School of dance and who also directed my musical *Rubirosa* at the Playwrights Horizons theater in New York. Marceau taught me the magic of mime, where silence becomes the language.

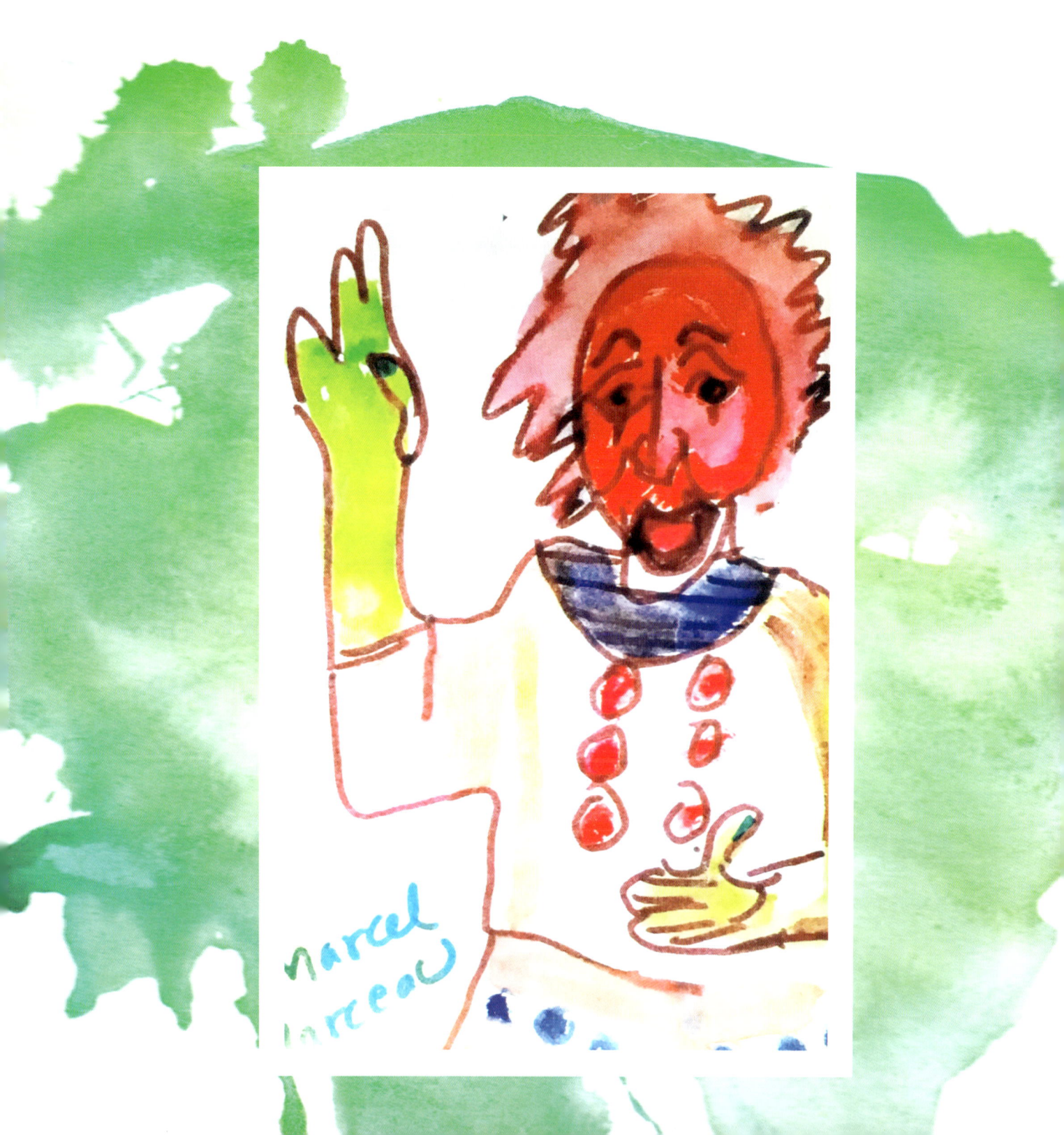

Marianne Moore

November 15, 1887 – February 5, 1972

Miss **MARIANNE MOORE**, as I called her, was an eccentric white-haired woman who lived in Brooklyn. She always wore a tie and a black tricorne hat, and created out of language poems that I believe will last forever. When I gave a poetry reading many years ago at the Y on 92nd Street, I was introduced to the audience by the brilliant Marianne Moore. Miss Moore had a quiet sense of humor. Later, when several years had passed since that reading, and I was living and writing poetry in Hong Kong, I self-published my poems at a Chinese printer. In the Chinese fashion, the book was as long as an arm and the cover was made of dark blue silk. I sent copies of the book to one hundred people I admired most, including Marianne Moore. At a book-warming party at the Gotham Book Mart in New York City, Miss Moore came up to me and said, with a sly smile, "Sandra, thank you so much for sending me that beautiful pair of silk pajamas."

Milos Forman

February 18, 1932

The Oscar-winning director **MILOS FORMAN** credits me for creating his career in the United States. Once upon a time, I received a telegram from producer Daniel Selznick inviting me to the opening of a new film, *Taking Off*, directed by a totally unknown young Czechoslovakian director by the name of Milos Forman.

I loved the film. Sometimes, as Polish novelist Joseph Conrad did with his great novels about England, it takes a foreign eye and sensibility to see a country's problems for what they are. Forman saw American society through European eyes. His film nailed the great problem of the huge gulf between generations in America in the 1960s. His film was about teenagers who had run away from their parents, and abandoned parents who wore name tags in large meetings where they'd come to share and vent their anger and bewildered feelings about losing their beloved children. I found this film to be a masterpiece. Unfortunately for Milos, the *The New York Times* film reviewer, Vincent Canby, trashed the film. I became furious. I quickly got on the phone and complained to the editor in chief, Arthur Gelb, that the Canby review was asinine.

"Would you like a page to refute Vincent Canby?" Gelb asked.

"Oh my God! Yes!"

I wrote that Milos Forman was a genius. He proved me right not only by winning two Oscars but also with his brilliant direction of the great American musical *Hair*.

Ten years later, Arthor Gelb invited me to be the film critic for *The New York Times*. I turned him down because I couldn't bear to hurt any actor's or director's feelings, and because I appreciate most films.

Besides, geniuses like Milos Forman only come along once or twice in a lifetime.

Norman Mailer

January 31, 1923 – November 10, 2007

I met **NORMAN MAILER** at the actors studio in the playwrights unit. He came up to me and asked me to do him a favor. I told him it depended on what the favor was, as I was curious to see what I could do for him. "Would you take my daughter to lunch? You see, I want her to grow up to be like you—a poet." I told him that I would be delighted. His daughter and I went for lunch at the Russian Tea Room. I became friends with Norman and his daughter. When Ariel was born he sent me a gold baby cup from Tiffany's. On the cup, he had Tiffany's engrave six of his favorite words taken from many of my poems.

You ever read a
greater Poet in America?
Pablo Neruda
we met in Paris
and he asked me to
be his protégé.
We talked
poetry. He told
me his biggest
influence was
Nursery rhymes.
Yo Montd Love
Poems a 20 Love
Poems a Song
of lament
Changed my life

Sandra Hochman

Pablo Neruda

July 12, 1904 – September 23, 1973

When you enter my apartment, you can see a picture postcard tacked to the nearby bookcase. It's a Christmas greeting signed by the late **PABLO NERUDA** and his wife Matilda. I think he is, without doubt, the most important poet of the twentieth century. The picture smiles at me every time I enter my home. Neruda asked me to be his protégé when we both lived in Paris. I consider this my most important literary relationship.*

*If you are interested in learning more about our relationship, read *Remembering Paris 1958–1960,* a memoir published by Turner Publishing.

Pablo Picasso

October 25, 1881 – April 8, 1973

What Pablo Neruda is to poetry **PABLO PICASSO** is to painting, sculpture, etchings, and pottery. He was an original genius whose work will never fade. I keep a black and white ceramic vase of a woman's head that Picasso made on my coffee table. It is always filled with flowers. He once said to me, "There are only ten great painters in a lifetime." For me, he is number one. He is, and always will be, my favorite artist.

Paul Taylor

July 29, 1930

I always loved modern dance. In New York, after returning from Paris, Merce Cunningham, the great dancer, was my friend. Merce trained **PAUL TAYLOR**, whose dance company was innovative and staggeringly beautiful to watch.

Justin Colin once invited me to his hotel in St. Barts along with Paul Taylor, who came with his mother. I was there with my boyfriend Donald Towson. Justin was a patron of the arts. He loved my poetry and Paul Taylor's dance, so he gave a free offseason vacation to two of his favorite artists. No other guests were there. During that week, Paul and I became friends. It was the rainy season, so we spent a lot of time indoors. My boyfriend Don felt trapped in this beautiful hotel with two artists who bored him to death. He was a businessman who founded Tad's Steakhouse and had no interest in modern dance or poetry.

So while Paul's mother and Donald bonded, Paul and I got to know each other and had lengthy discussions about dancers and poetry. It turned out that Paul wrote poetry, and when I returned to New York, he sent me several of his poems, which were amazingly beautiful. He showed me his dance studio, which was then in New York and was the most elegant dance studio that I had ever seen. Unlike most dancers, he had a talent for getting grants and funding for his company. Paul proved to be not only a master of dance, but also of fundraising and organization.

His laid-back personality very much appealed to me because it belied a creative mind that could take a human body and make it respond to his ideas of dance. I like him so much because he is so talented and unpretentious. He is dynamic, poetic, and creative, and still choreographing to this day.

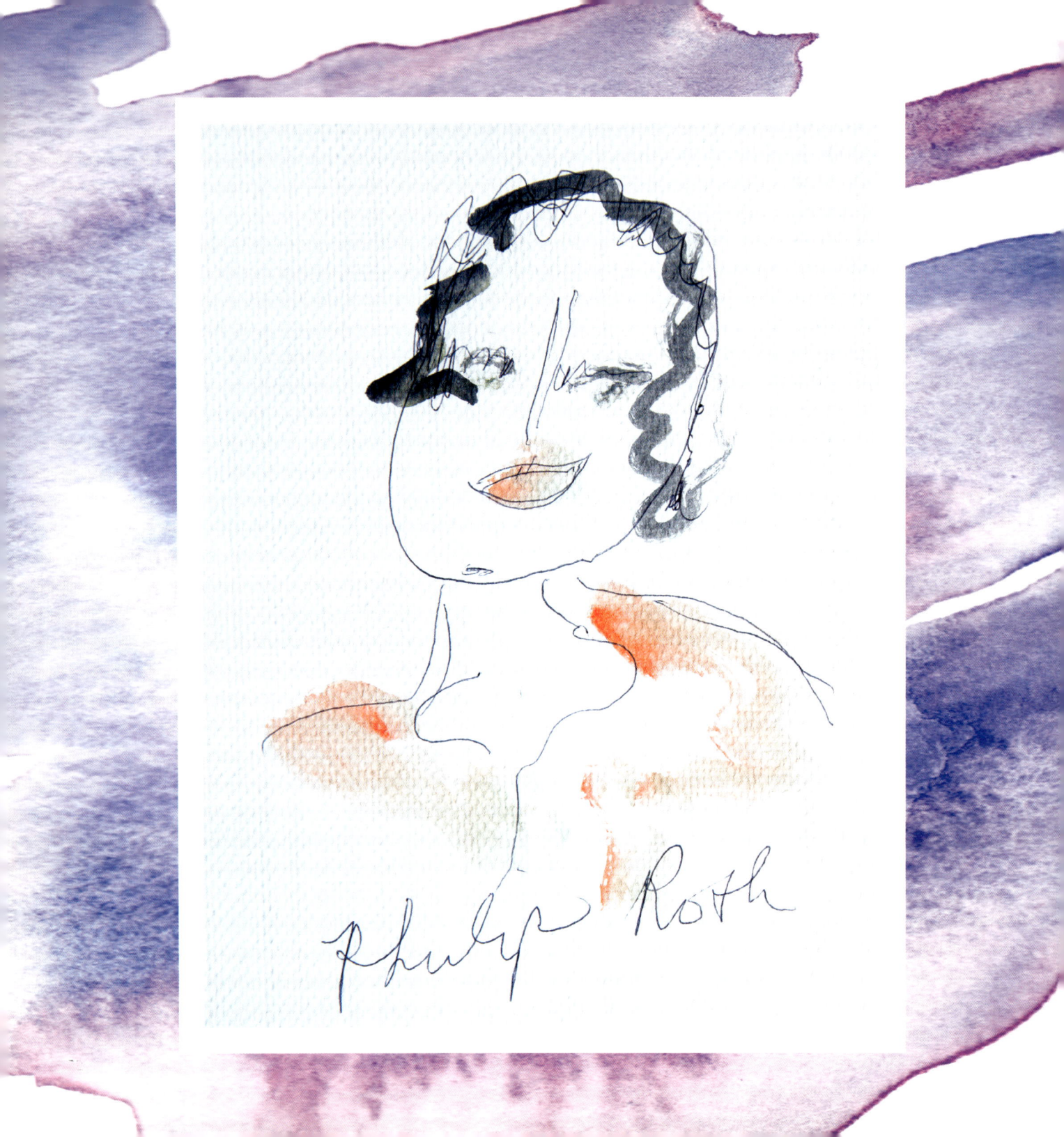

March 19, 1933

For better or worse, I credit **PHILIP ROTH** for my career as a novelist. Once upon a time, when I lived in a penthouse on East 79th Street, I was lying in bed along with at least two hundred sheets of paper with my handwriting on them. Philip came to visit. He had heard I was ill and was appreciative that I had written a book review of his novel *Portnoy's Complaint*. Many people claimed the book was anti-Semitic. I dared to disagree with this assessment in my review.

At the time, my thoughts were that America is a place where everybody wants to be what they are not. Jews want to be Christians and Christians want to be Jews, white people want to be black people (especially in the music business). His defiance of the laws of his religion was just part of the American melting pot. After my review was published, Philip and I bonded.

That day, Philip picked up one of the many papers surrounding me and started reading. He eventually scooped up all the papers and put them in his briefcase. He said he was going to tell his publisher that if they didn't publish this masterpiece novel that I had written, then he was leaving them. Viking published my "dirty feminist book" because they had to. The novel was titled *Walking Papers* and was ahead of its time. Philip is a very polite and decent human being. He's the most talented comic writer America has ever produced.

Ralph Ellison

March 1, 1913 – April 16, 1994

RALPH ELLISON wrote a beautiful and yet political book about being African American called *The Invisible Man*. I first read it as a student at Bennington. Ralph was a close friend of a spectacular professor, Stanley Edgar Hyman, who was married to the great short story writer Shirley Jackson, author of "The Lottery." Stanley invited Ralph to come and talk to the students at Bennington. I met him then, and we became friends soon thereafter. He was a brilliant gentleman, and I often re-read his book, which is still considered a classic.

Greatest
Novelists
of the
20th Century

Ralph Ellison

We became
friends when I went to
Bennington College.

Sandra
Hochman
2016

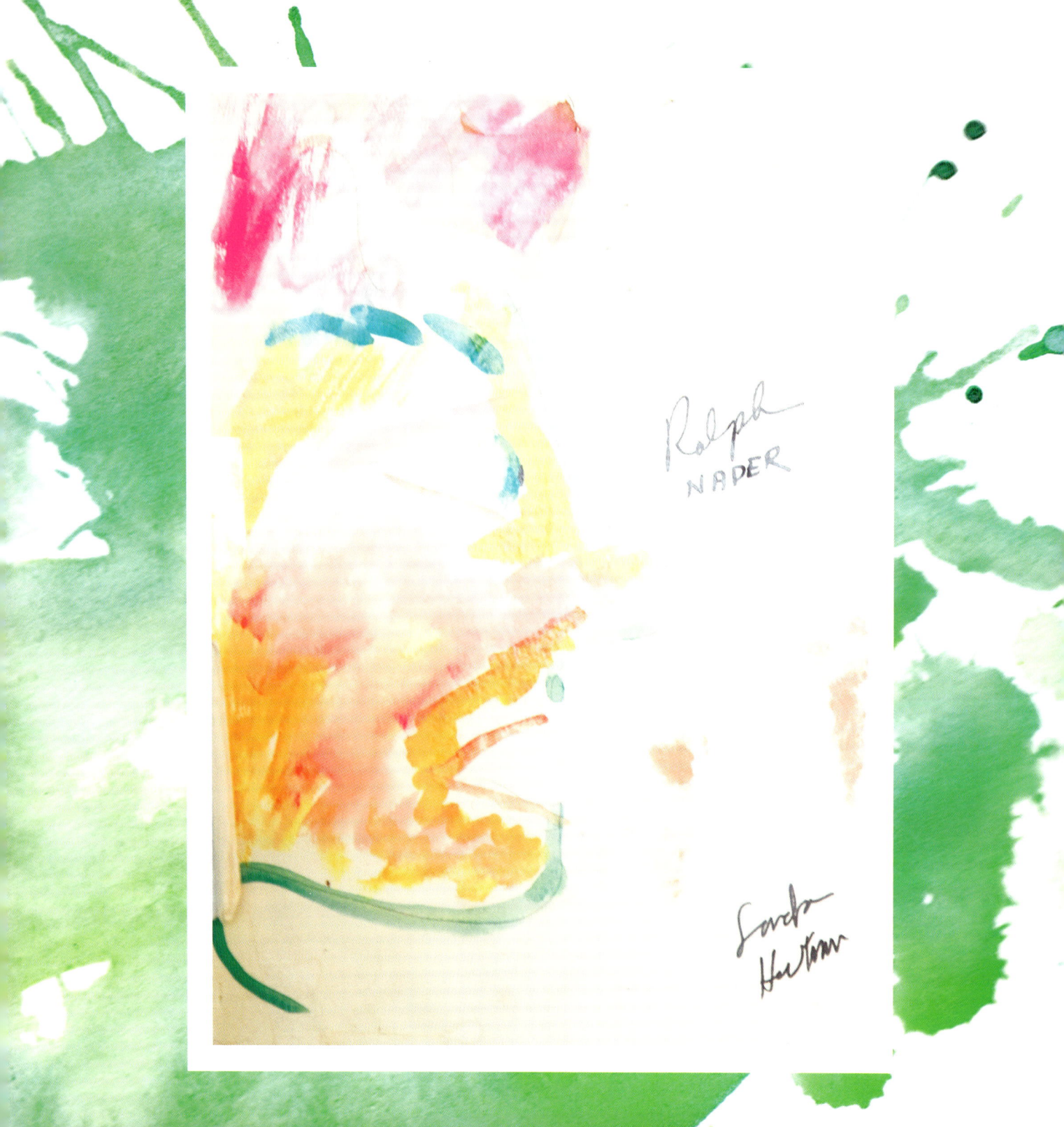

Ralph Nader

February 27, 1934

RALPH NADER is a charming man who attended Princeton. However, the Princeton clubs didn't want him because of his Lebanese pedigree. He was a good friend who once told me how he managed to enlist thousands of young people into his Green Party. He figured that the idea of putting a check box on college applications would be the best way. Every student applying to college or university was given the choice to check yes or no when asked if they would like to join the Green Party. So many young kids checked the box that said yes without even knowing what the Green Party was.

During one of our conversations, I asked him why he didn't write a book for children on being a consumer. He simply said that he wasn't interested in children because they don't vote. Once I heard that, I decided to become a child advocate, and that became one of the reasons that I created a non-profit foundation with Teddy Rosenthal. The foundation funded the after-school programs at the Metropolitan Museum of Art for children to learn how to write. Writing was, and still is, a political tool. Teddy and I gave that tool to many children. In the hands of the right people, writing can change the world. Thank you, Ralph. Sometimes insensitivity leads to revolution.

Robert Lowell

March 1, 1917 – September 12, 1977

I assisted **ROBERT LOWELL** in writing *Imitations*. It was one of the greatest thrills of my life. As the critic Edmund Wilson said, *"Imitations* is, so far as I know, the only book of its kind in literature." After T.S. Elliot, I believe Lowell was America's greatest poet. He was also a charming and generous man. God bless him.

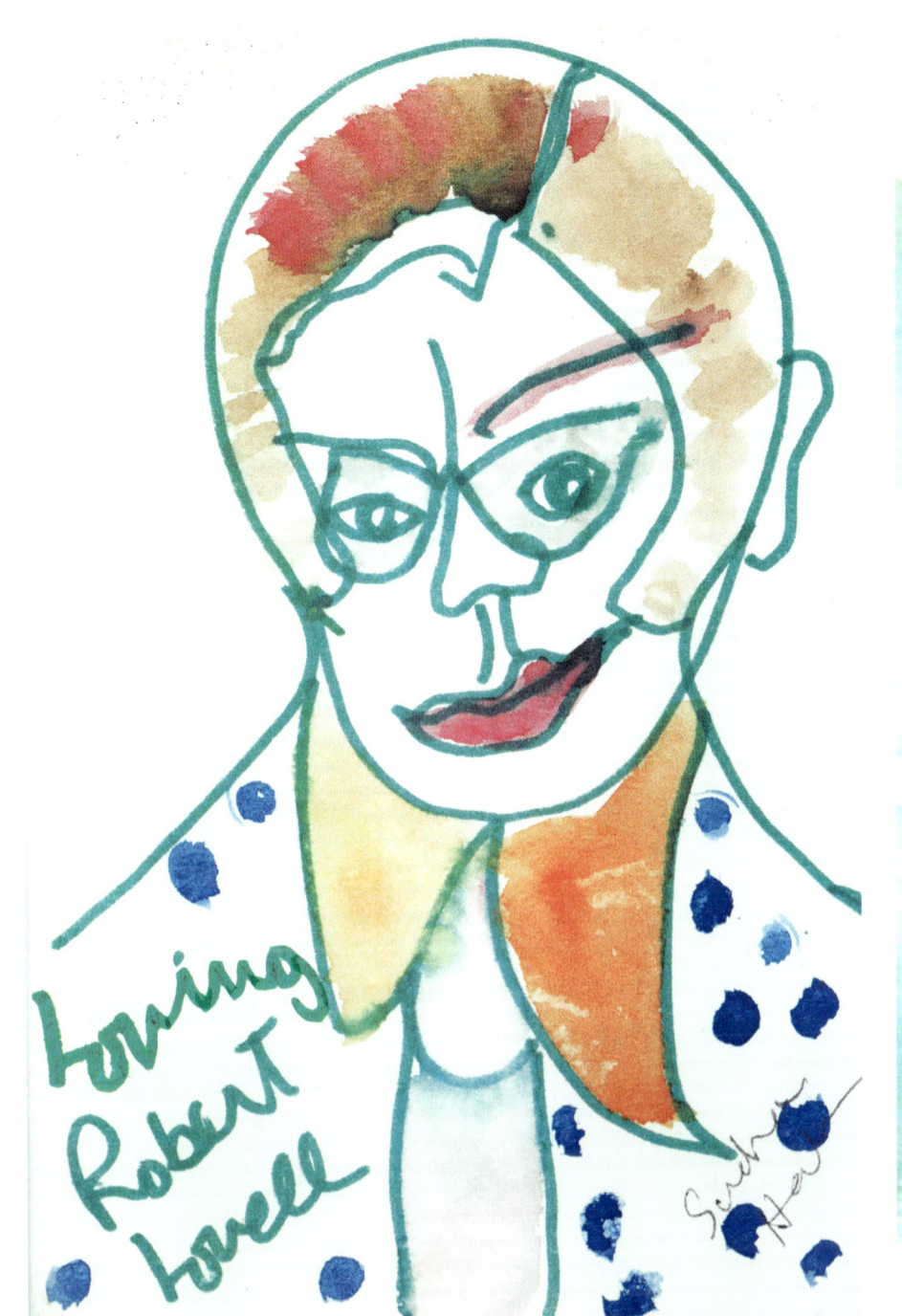

Samuel Beckett

April 13, 1906 – December 22, 1989

I was introduced to the great **SAMUEL BECKETT** by the Irish poet George Reavey when I was in my twenties. We all went to have beer. Needless to say, I was a tiny bit thrilled. Oscar Wilde? William Butler Yeats? Sean O'Casey? Oh, thank you, Ireland, for giving the world many of its great writers.

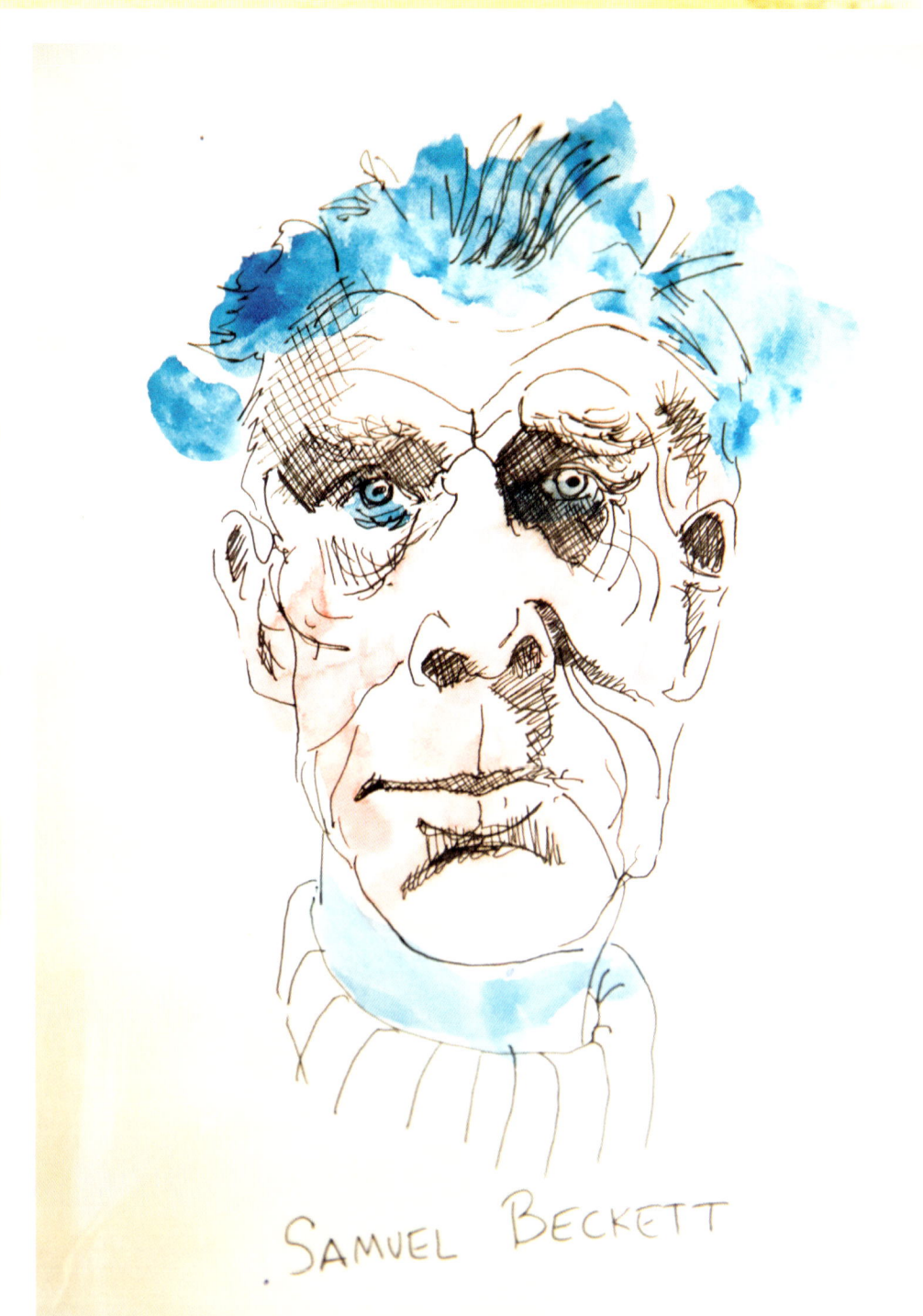

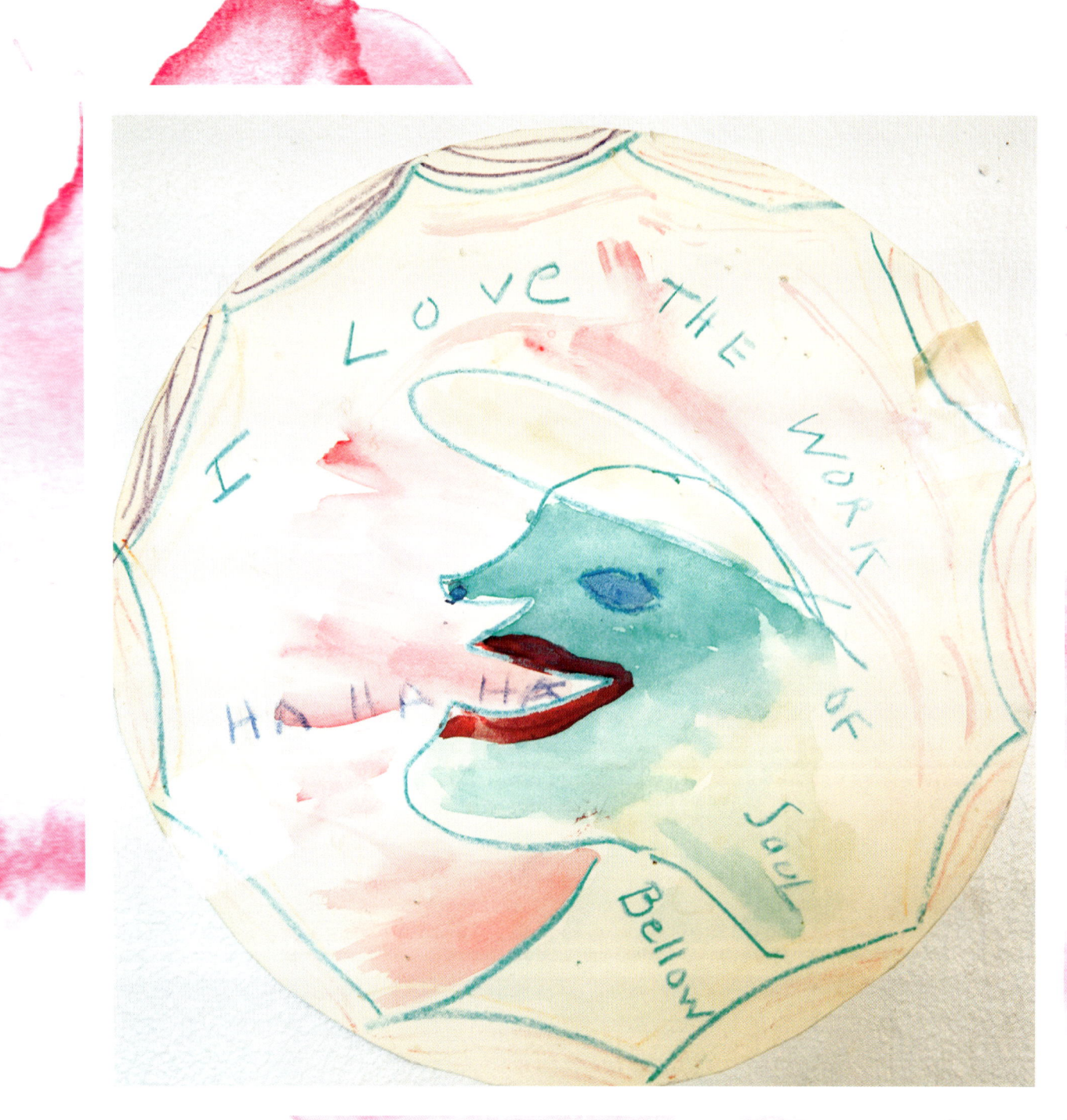

Saul Bellow

June 10, 1915 – April 5, 2005

It's hard to write anything about **SAUL BELLOW** because, for a while, he was my loving boyfriend and asked me to marry him. Be the wife of the man who wrote *Herzog*? I'm now sorry I didn't. But at the time I thought I'd never marry a celebrity artist and never marry a writer. However, I loved Saul's writing, and he was, without doubt, the smartest man I ever met.

Sheldon Harnick

APRIL 30, 1924

SHELDON HARNICK is the genius behind the great musical, inspired by the short stories of Sholem Aleichem, *Fiddler on the Roof.* I suggested to Sheldon many lyrics which he wrote for many hit shows like *Fiddler on the Roof,* along with other songs that will remain forever. The more I sing the songs, especially "Sunrise, Sunset," the more I realize what a great poet Sheldon Harnick is for the world. His sense of humor in "If I Were a Rich Man" is divine.

Sheldon Harnick lyricist

No one not even Cole Porter had his sense of humor wit. "Fiddler on the Roof" is a musical for the ages.

s.perlman 2016

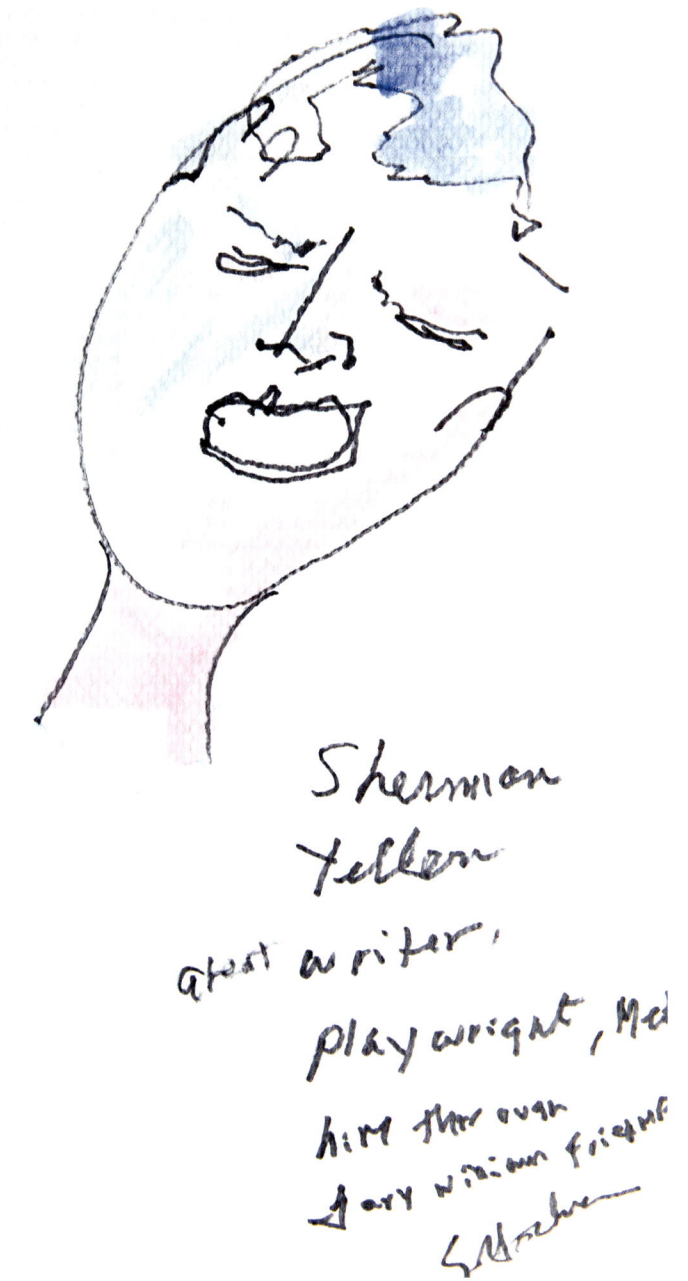

Sherman
Yellen
ghost writer,
playwright, Mel
his through
Gary William Friedman
S. Yellen

Sherman Yellen

February 25, 1932

SHERMAN YELLEN lives a few blocks away from me. I once invited him to a reading of my poems by the great English actress Julia Sands. His thank-you letter was so gracious, so kind, and so beautifully written. It's no wonder that the Broadway musical he wrote with Bach and Harrick, *The Rothchilds,* was a hit all over the world.

Sylvia Fine

August 29, 1913 – October 28, 1991

SYLVIA FINE was a lyricist in the same class as Cole Porter whose linguistic genius made her create outrageous songs, mostly for her husband, Danny Kaye. As a little girl in boarding school, I played recordings of Danny singing her songs. I memorized "Anatole of Paris":

> I shriek with chic
>
> My hat of the week
>
> Cause six divorces, three runaway horses ...

And I realized that Sylvia's songs could twist rhyme and language to make us laugh.

Many years later, I met Sylvia at the home of ambassador Marietta Tree. We became instant friends despite the difference in our ages. Because of her encouragement, I have written musicals with great composers such as Gary William Friedman, Galt MacDermot, and Gary Kupper. Sylvia inspired me to write lyrics for six musicals. She was one of the few composers, like Stephen Sondheim, who wrote not only lyrics but also her own music.

She was also a very good friend who invited me to her home in Hollywood, where I held a poetry reading for all of her A-list friends—Barbra Streisand, Kirk Douglas, Vincente Minnelli, and many other stars. Sylvia was witty, generous, and encouraging to young people.

Sylvia Fine was one of my best friends and wrote a song for Ariel when she was born. She encouraged me to be not just a poet but a lyricist.

S. Herman
2016

Truman Capote

September 30, 1924 – August 25, 1984

I hate to see a dog piss on a fire stand, and I hate to see a critic piss on a great writer in print. When **TRUMAN CAPOTE'S** novel about two murderers, *In Cold Blood*, came out, Kenneth Tynan, an English critic, wrote a scathing review. As it happened, my second husband, Harvey A. Leve, had a book in his bookcase by Ken Tynan about how marvelous it is to go to a bullfight. I've never been to a bullfight, but if I did attend such a gruesome event, I would root for the bull. I love animals. And so I wrote an article against the hypocrisy of Kenneth who thought it was "cruel" and "disgusting" for Capote to write a book exploiting murderers. I wrote, "Tynan exploits the murder of bulls, but his condemnation of a magnificent novel is nothing but jealousy and bullshit."

While sitting at the pool at the Hong Kong Hilton Hotel, a page handed me a letter. It was written in the handwriting of a child. Every word was carefully printed. But it wasn't from a child. It was from Truman Capote. He was thanking me for "sticking up" for his novel. That began a correspondence and a friendship that lasted until he died.

W. H. Auden

February 21, 1907 – September 29, 1973

One of the greatest thrills of my life was being invited to the home of **W. H. AUDEN** by his lover, Chester Kallman. I was nervous to visit his home, as Auden was one of my literary heroes. I had learned so much from reading his poetry. I was welcomed into the home of Auden and Kallman on the Lower East Side. Auden didn't seem to be pleased by Kallman's enthusiasm about me as a new friend. His voice was lower and his face very wrinkled. He began to question me. I was very young and frightened I would give a wrong answer. He had asked me who my favorite writer was, and I froze. I finally found my voice and answered that it was Colette. He smiled a huge, loving smile and replied that his favorite writer was Colette as well. We moved on to having a lovely lunch and chattering about Colette's young women, especially Chéri. I overlooked the fact that the apartment was filthy and that the food was awful. The discussions about Colette were better than the best food in the world.

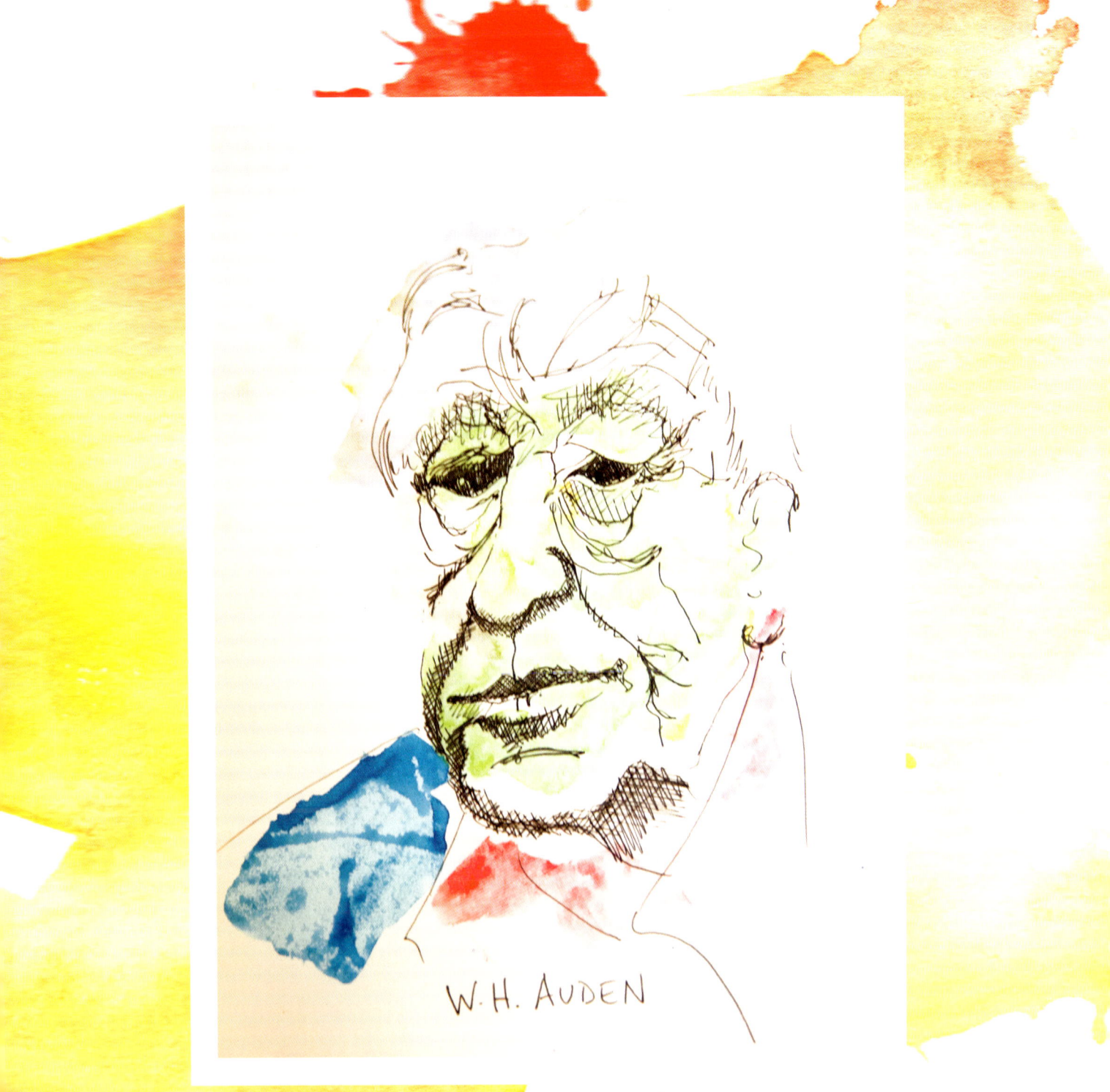

William Greaves

1 of the great political filmmaker. He helped me cast my own play "the Sandbox"

Film genius Renaissance poet, guru, actor, dancer + great friend!

S. Hochman
2016

William Greaves

October 8, 1926 – August 25, 2014

WILLIAM GREAVES, from Harlem, New York, was the major African American filmmaker of my era. He kindly gave me some clips from his masterpiece, *The Harlem Renaissance*, to be shown in my musical *The Sand Dancer*, which was about the African American tap dancer, Howard "Sandman" Sims. Greaves always attended my annual birthday party and brought me beautiful presents, one of them being an exquisite black box from India, which I treasure. His films will live on forever.

Epilogue

It hurts like a terrible slap
These frightening words of goodbye
And it shatters my world
That some no longer live
Why did so many friends have to die?

It hurts like a terrible slap
And I suddenly feel it's not fair
That the flames that lit my novels and songs
Are suddenly blown out into air

I will see them always in the eye of my heart,
I will hear their voice with the ear of my soul,
I will trace each face on the path of the sun
Till the bells of my own death toll

I will say their names
Every night in my prayers
I will hear their voices as I'm writing alone
In this book they will live on

For an artist, there is no truth in death.